The Erotic                    The Valorous                    The Furious

# The 9 Emotions
## Of Indian Cinema Hoardings

The Terror-stricken              The Pathetic                    The Comic

By V. Geetha, Sirish Rao, M.P. Dhakshna
Tara Publishing

The Disgusting                  The Marvellous                  The Peaceful

'People say I overact.
But isn't all acting overacting?'

– Legendary actor Sivaji Ganesan, 'King of Nine Emotions' (1927–2001)

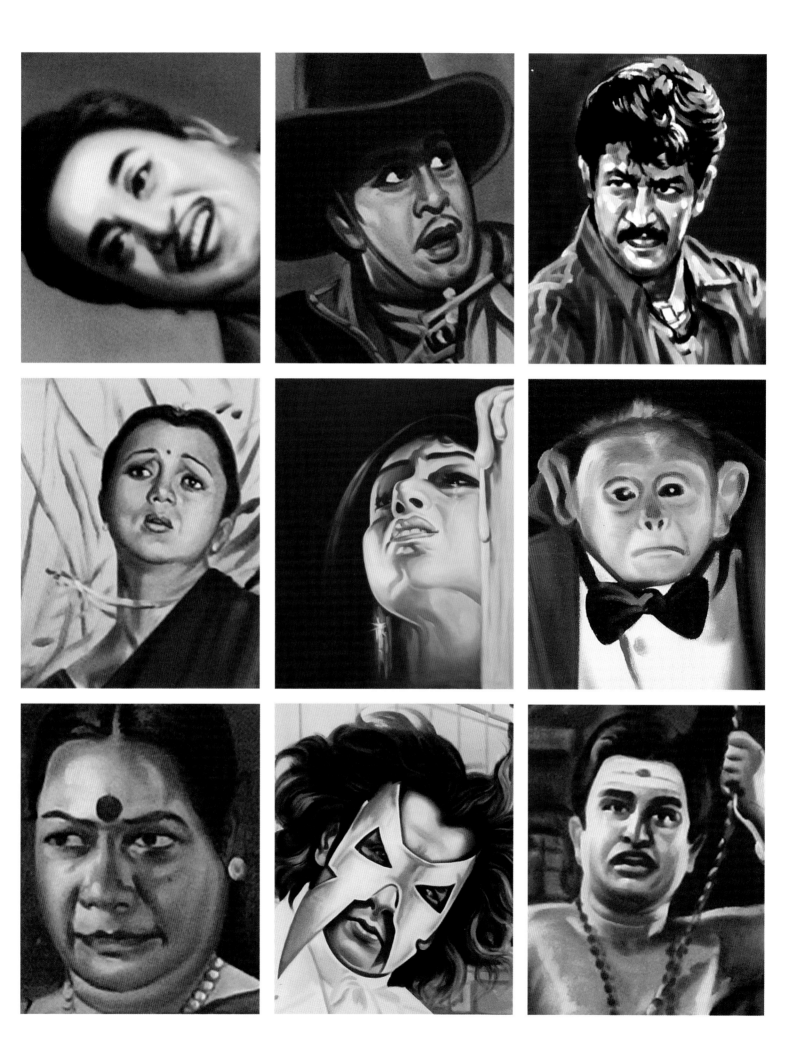

All art is a product of artifice, according to *Natyashastra*, the second century text on Indian aesthetics and performance. The power of make-believe works by evoking for the audience a sense of relish – or *rasa*, as the Sanskrit has it. To be successful, performers must be able to emote a total of nine emotions – or the *Navarasas* – set out in the text. This ancient theory has endured in a classical sense: for one, the emotions it mentions are universal, recognisable across ages and cultures.

But even more interestingly for our purposes, the theory lives on in common memory in India, leaving its traces in performing forms ranging from rural theatre to popular cinema. The huge film hoardings that dominate city roads in much of southern India rely on compelling renderings of these emotions to advertise films: heroic, virile men with swords and pistols on the draw; moustachioed faces contorted with red rage; lovers swooning under a glistening yellow moon…

This is the point where all the different strands of this project come together.

As lovers of the vibrant – but sadly disappearing – art form of handpainted cinema hoardings, we had always been looking for creative ways of working with it, as insiders from within the culture. We wanted to go beyond the fashionable trend of celebratory Bollywood kitsch – to be playful, yet true to the original syntax and respectful of context, to work closely with the modest people whose colossal installations dominate our streets, not just use their work without acknowledgement.

Then we hit upon the theory of the nine emotions as an inspired conceptual framework, to try a bold experiment. We decided to create a piece of artifice – albeit founded – by asking artists to illustrate each of the nine emotions in the idiom of popular Tamil cinema billboards, the huge advertisements commonly known as 'hoardings.' Each painting in this book, therefore, has been created specially for this project. But it takes its cues from actual film stills and promotional images, all the while firmly embedded in its own unique grammar, although without the text that usually accompanies it. The visuals were created by a team of young artists, headed by master painter M.P. Dhakshna, considered one of the finest working in the genre.

For us, keeping the universality of emotions as a trope has another central function: it allows just about every viewer an entry into the art. You do not have to know the actors and actresses, or the films, to be drawn into this bizarrely enchanting world. Each painting is set off by a piece of text drawn from the original *Natyashastra* juxtaposed with snippets of popular film songs. So aesthetic theory, the world of cinema, and poster painting mingle in the most unexpected ways, in this coming together of art and performance.

The initiated will find much to discover – from well-known faces, films and eras in the paintings to the detailed essays and analyses at the end of the book. We hope you will be as beguiled as we are in our quest to capture a world we delight in, even as we try to understand it critically.

– V. Geetha, Sirish Rao and Gita Wolf

Shringara
# The Erotic

The sentiment of *Shringara* – the erotic – has its origin in the permanent mood that is love. It is marked by gaiety in dress and draws to itself all that is pure, gay and worth seeing in this world. There are two kinds of Shringara – love in union and love in separation. Pleasant seasons, garlands, unguents, ornaments, loved ones, especially the beloved, music, beautiful houses, gardens – love in union is associated with all of these. Love in separation causes longing, weariness, envy, despondency, self-disparagement, madness, which leads to distraction and death…

From *Natyashastra*

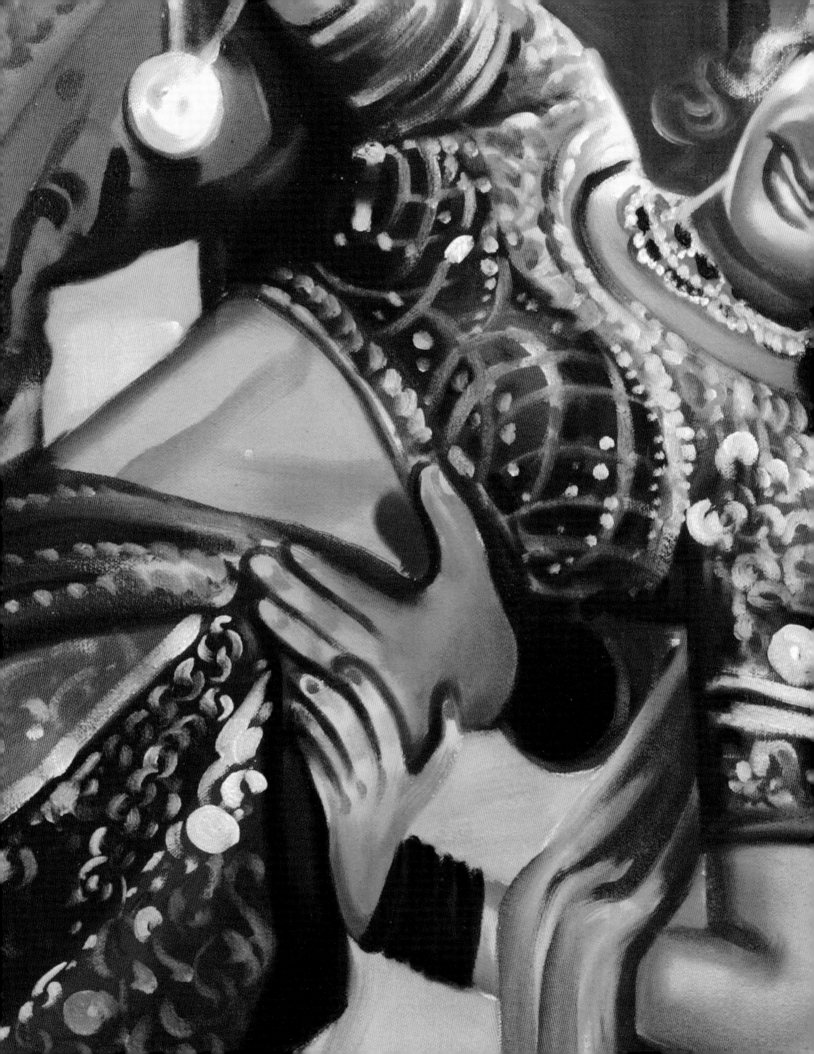

The heart knows a thousand entrances
And nurtures a thousand thoughts,
Who knows who enters and who departs?
If the heart is home to one alone
Then sorrow is kept at bay,
But if another comes while the one is there
Peace stays away.

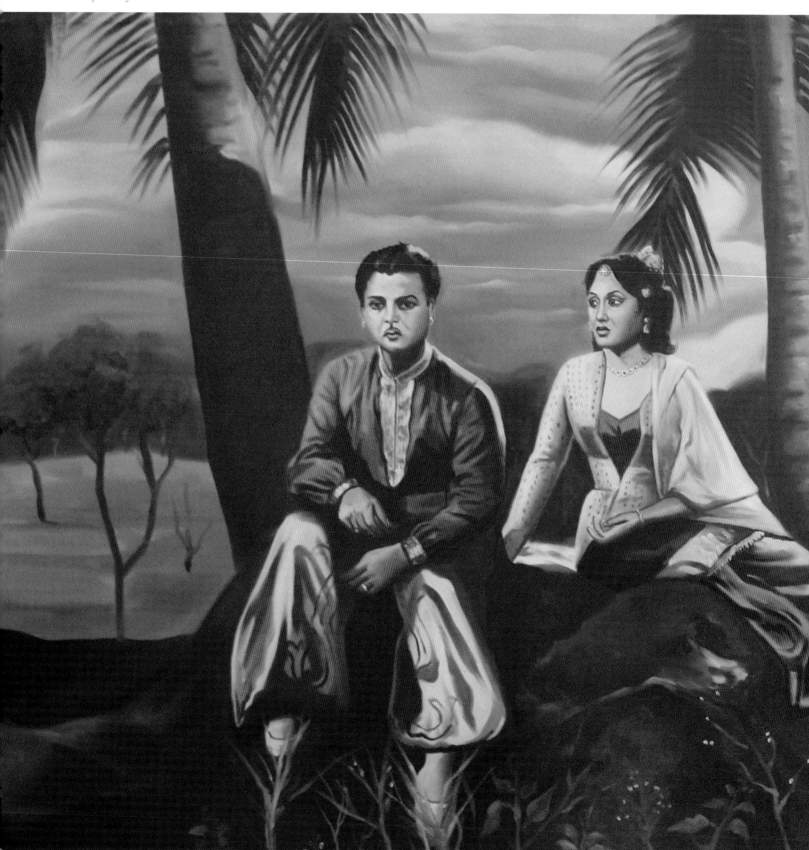

Film lyrics from *Nenjil Oru Aalayam* (Temple of the Heart)

If you are the eyes, I am their lashes
If you are the wind, I am the creeper
A tree, if you are the earth that holds it
The green of the field, if you are the rain.

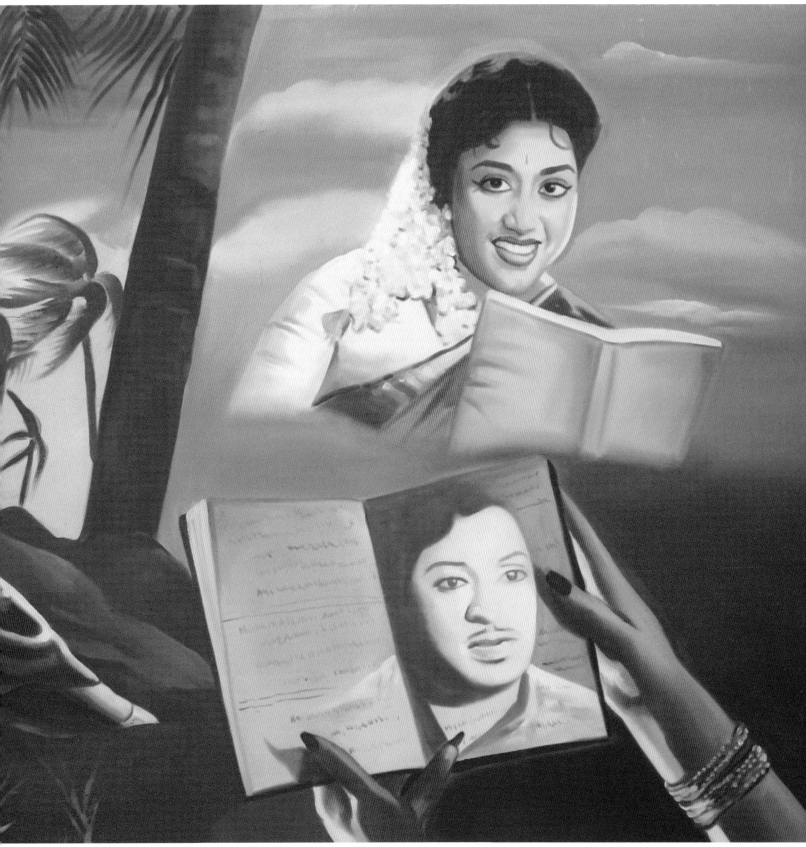

Film lyrics from *Sharada*

Oh, my joy, my king
Who cannot stop giving…
Here I am, a pavilion of sugar
Come, rain down your honey-drops.

When I sing, I am the gentle south wind…
That sways your tender body and draws it close,
Drinking honey off your lips
I enact this pleasure-play.

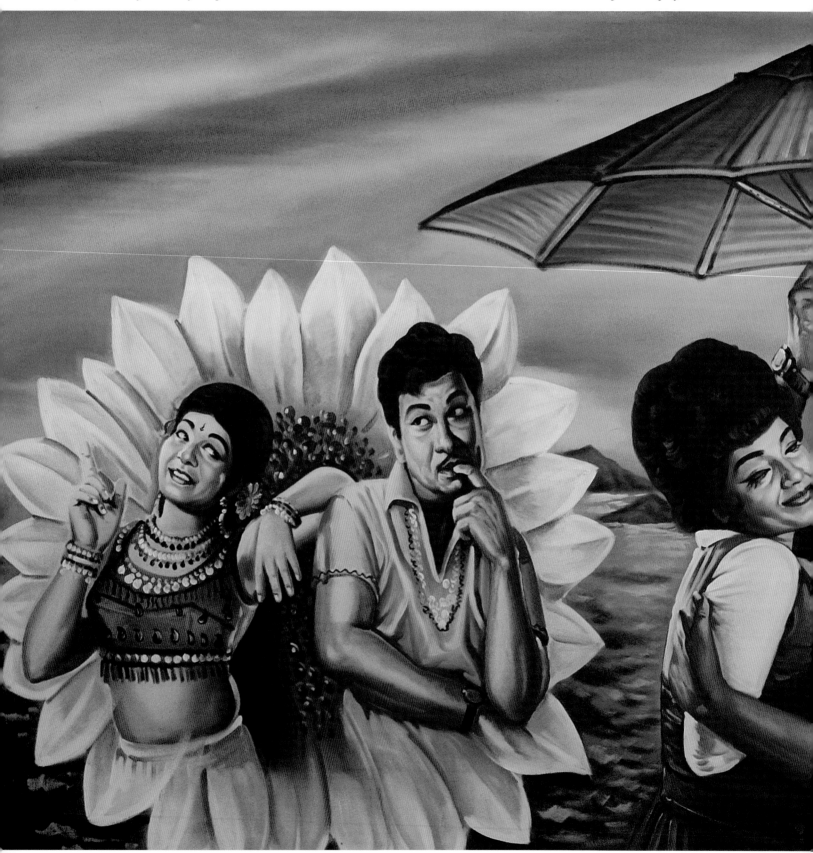

Film lyrics from *Idaya Kani* (Fruit of My Heart)

Film lyrics from *Nettru, Indru Naalai*
(Yesterday, Today and Tomorrow)

As my arms wrap around my love,
**My monarch's shoulders,**
My rippling dark hair becomes a mat,
My eyes redden, my mouth blanches.

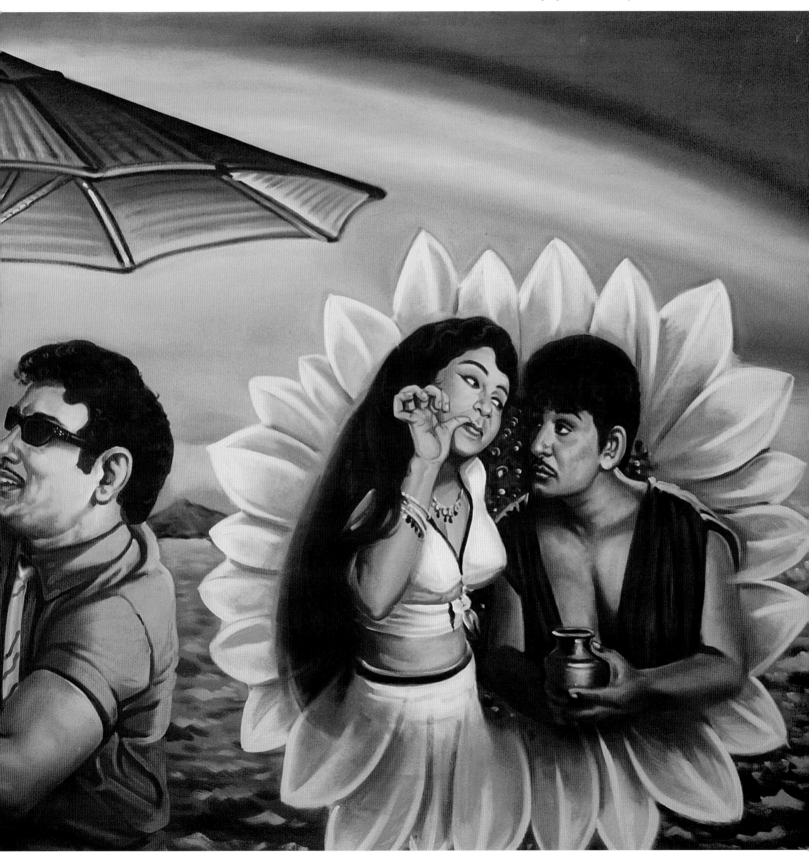

Film lyrics from *Adimai Penn* (Slave Girl)

A lovely girl by my side
And there's music all around,
And whatever I touch
Gives me pleasure, not pain.

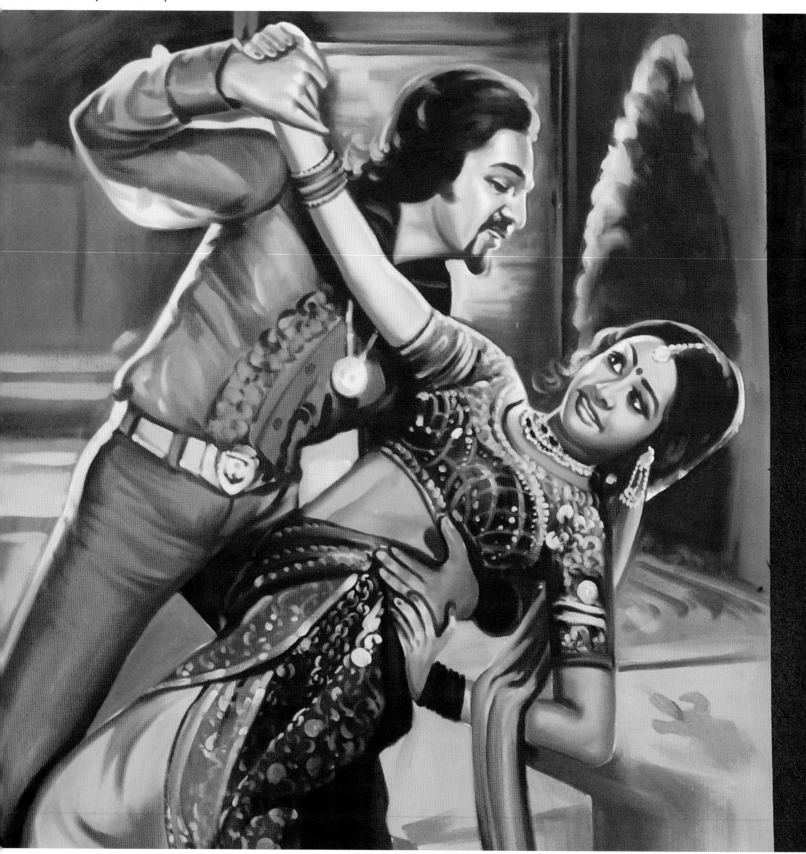

Film lyrics from *Ninaithale Innikum* (To Remember is to Relish)

Every day and by the hour,
I feel the ebb of desire,
And quick passion that leaves me wanting,
What is this but the happiness of youth?

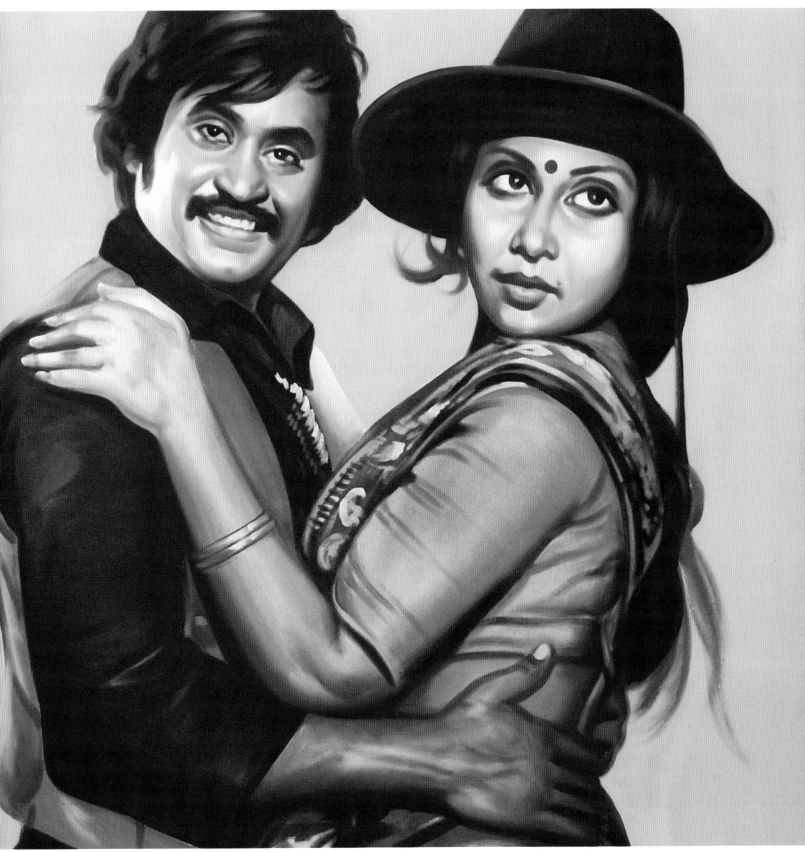

Film lyrics from *Aarilirundhu Arrubathu Varai*
(From Six to Sixty Years)

I stood at the water pavilion,
And he was there, saying he was thirsty,
I stood there all by myself,
And yet he said, 'I feel passion.'

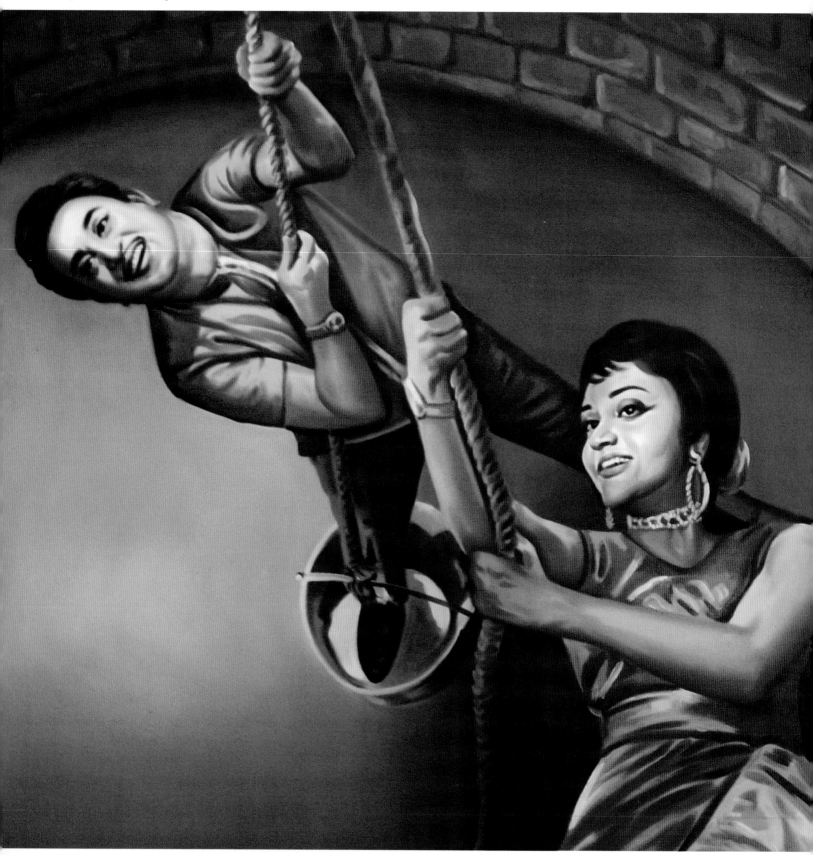

Film lyrics from *Enga Veetu Pillai* (Son of Our House)

I kissed you once,
And it drove you so mad
That you danced your mind away,
What if, like the never-ending monsoon rain,
I kiss you endlessly?
What then?

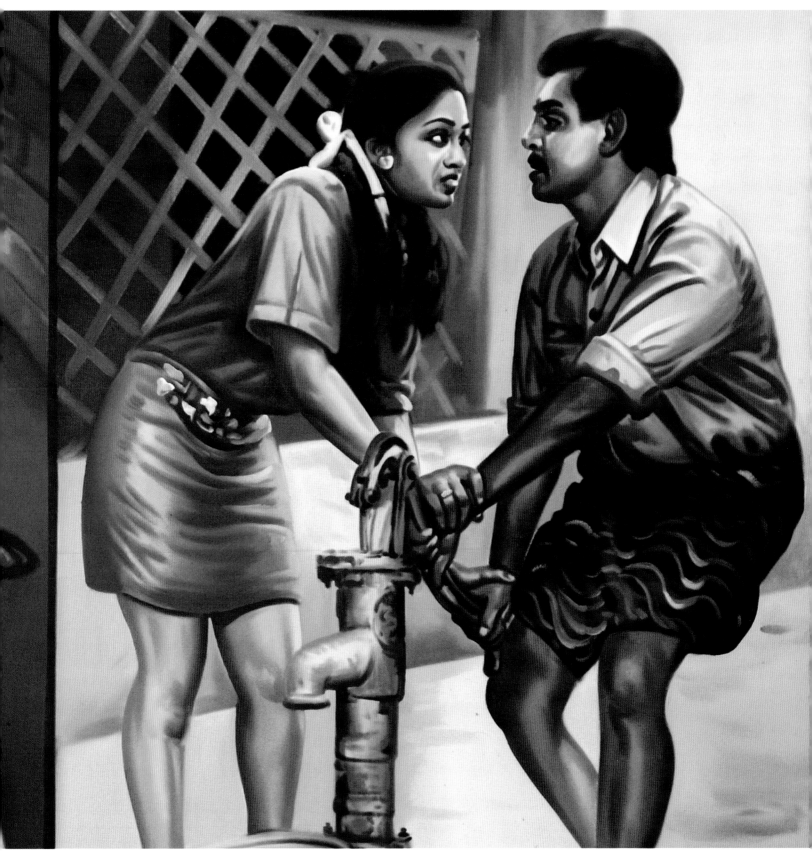

Will the winds of youth blow again?
And will they like my song?
**Will there be a woman's lap**
**To rest, as if it were my mother's own?**
Why sorrow, the sky never shrinks,
Don't pine away, the world can't bear it,
This can't be, for the sun never darkens.

**Film lyrics from *Mudal Mariyathai* (First Honour)**

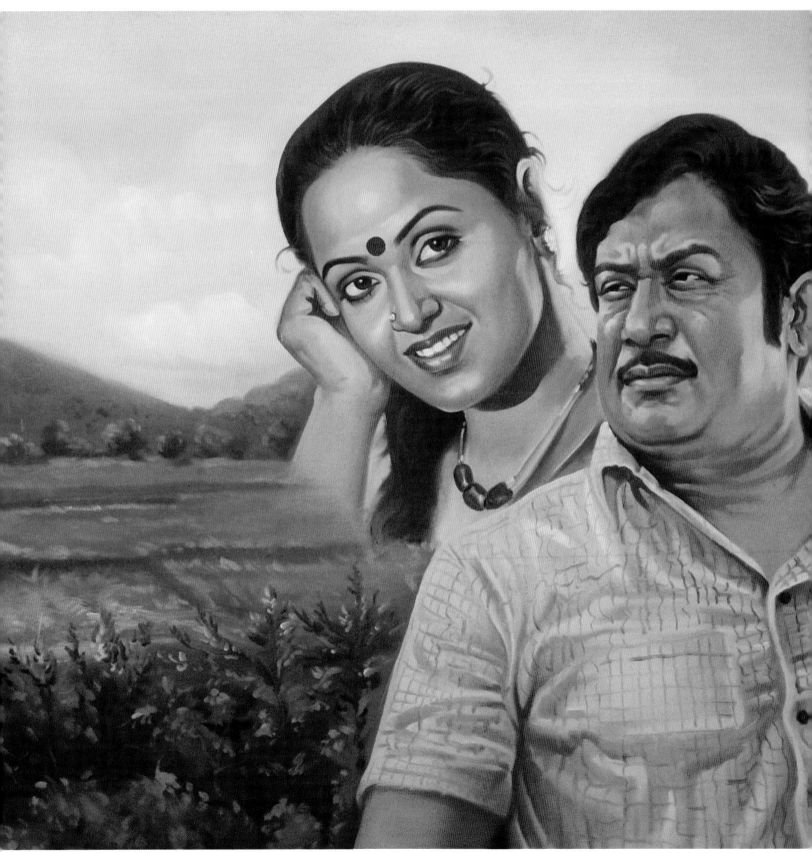

Love, my love, don't kill me,
Eyes, your eyes, they tease me,
Woman, don't burst my heart with your smile,
And, oh, in your eager hunger,
Don't drain my life away.

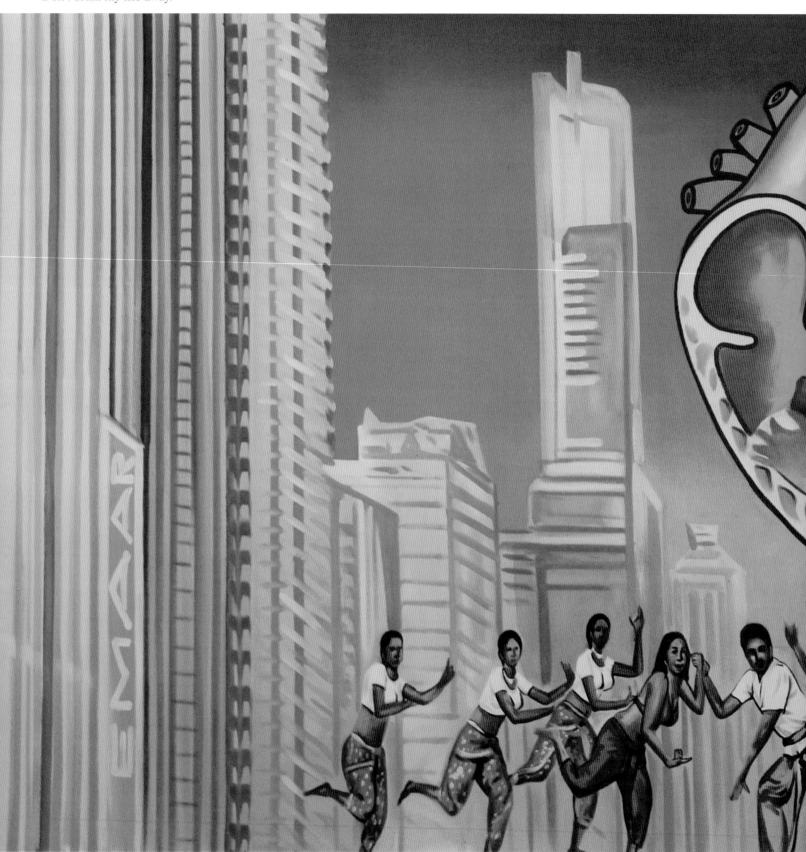

Film lyrics from *Jeans*

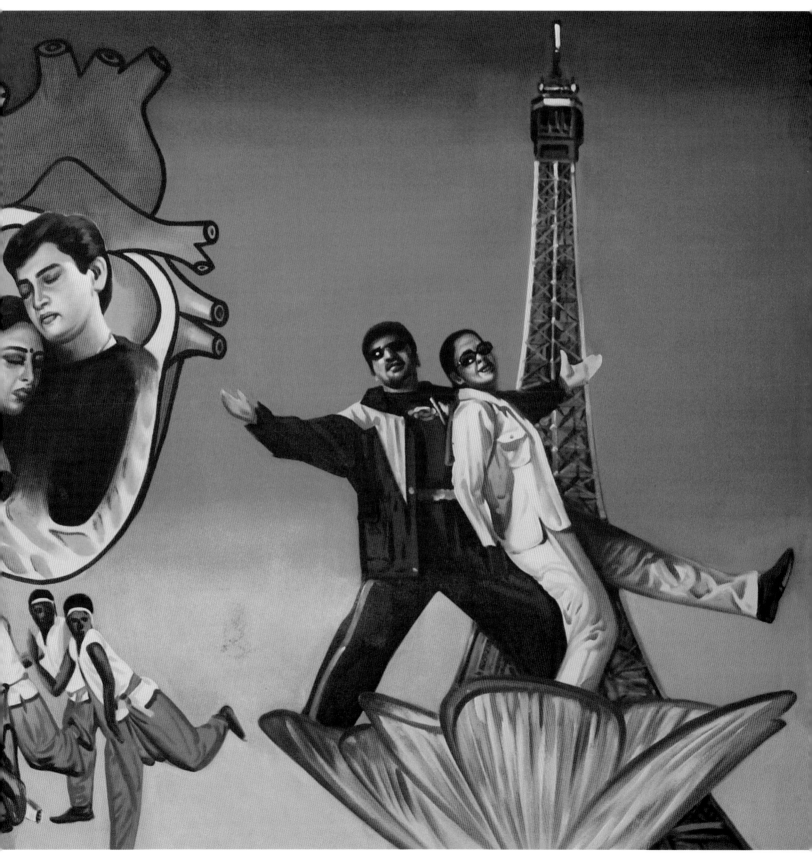

Vira
# The Valorous

Heroism or *Vira* is associated with those who possess superior dispositions and character. It brings forth diligence, composure, induces humility, results in acts of prowess and violence. Those who are heroic display firmness, courage, the spirit of renunciation… are haughty, stern...

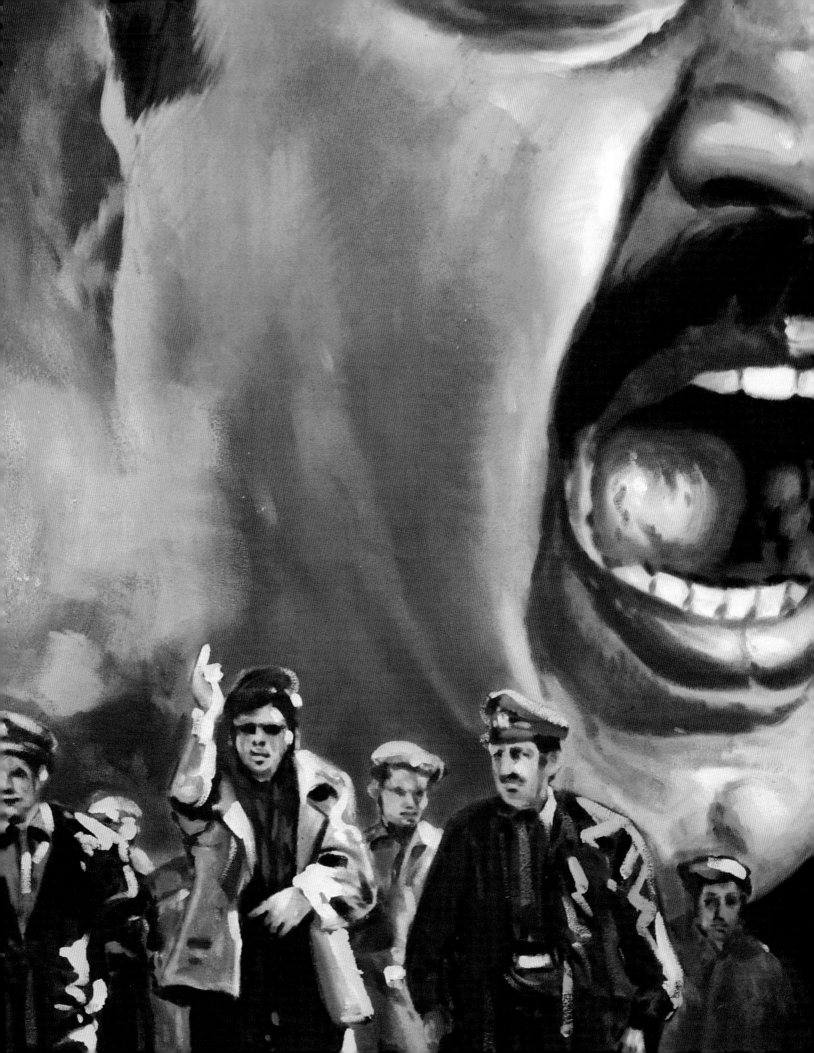

Let things happen as they must,
Let justice dissolve into the dark,
But know this:
One day it will reappear, bright and clear,
For he is there, our hero.

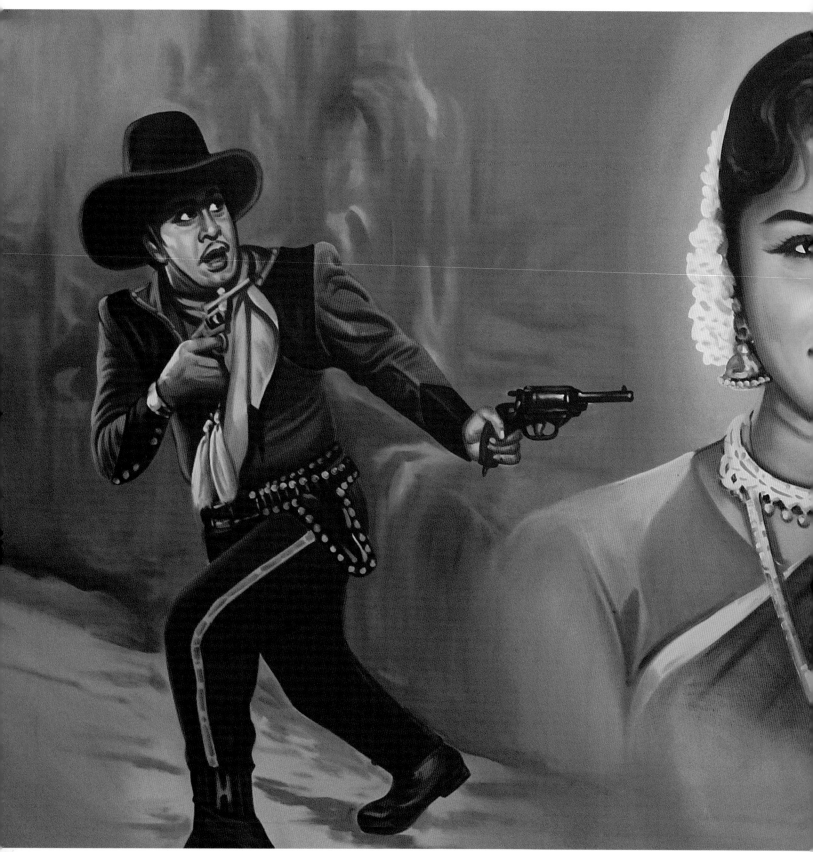

Film lyrics from *Panathottam* (Garden of Wealth)

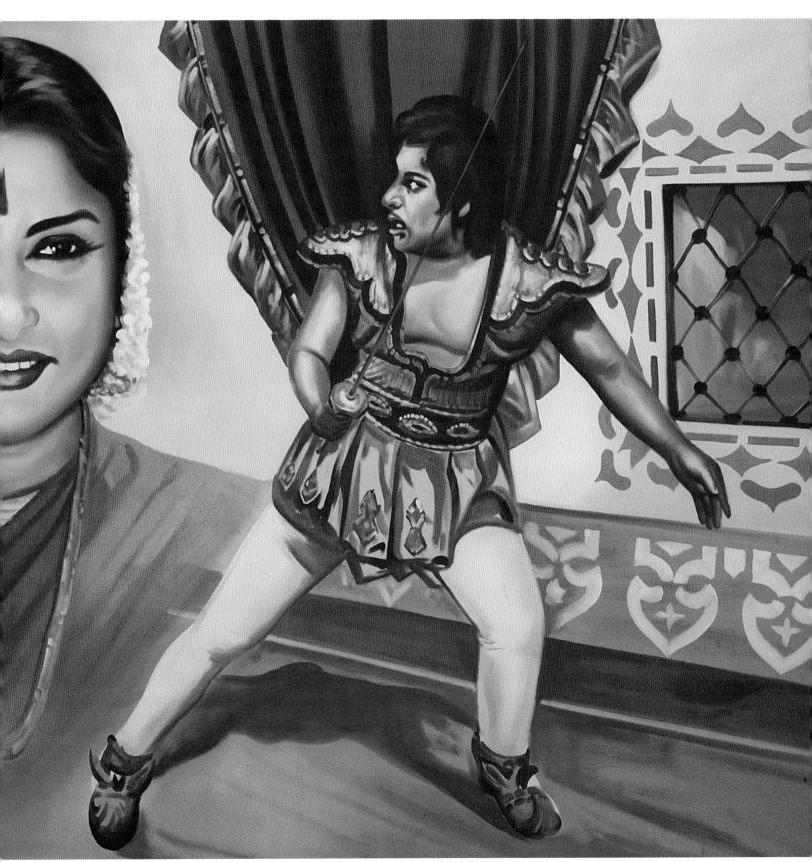

My heart is made of gold,
But when you challenge me
I turn into a lion,
I speak the truth and I do good,
And victory follows me.

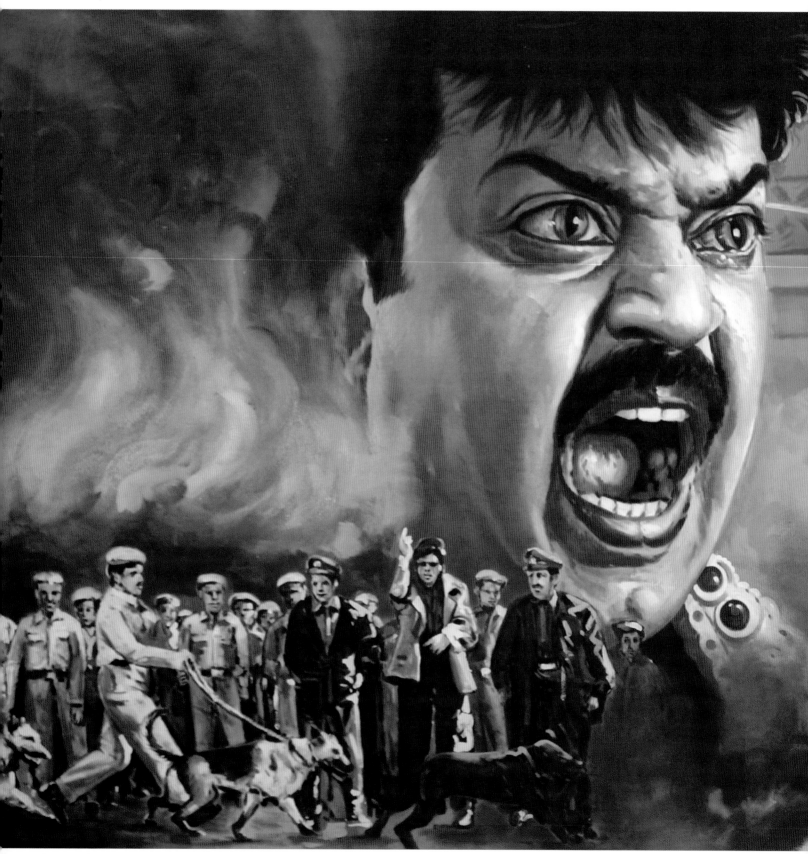

Film lyrics from *Murattu Kaalai* (The Wild Bull)

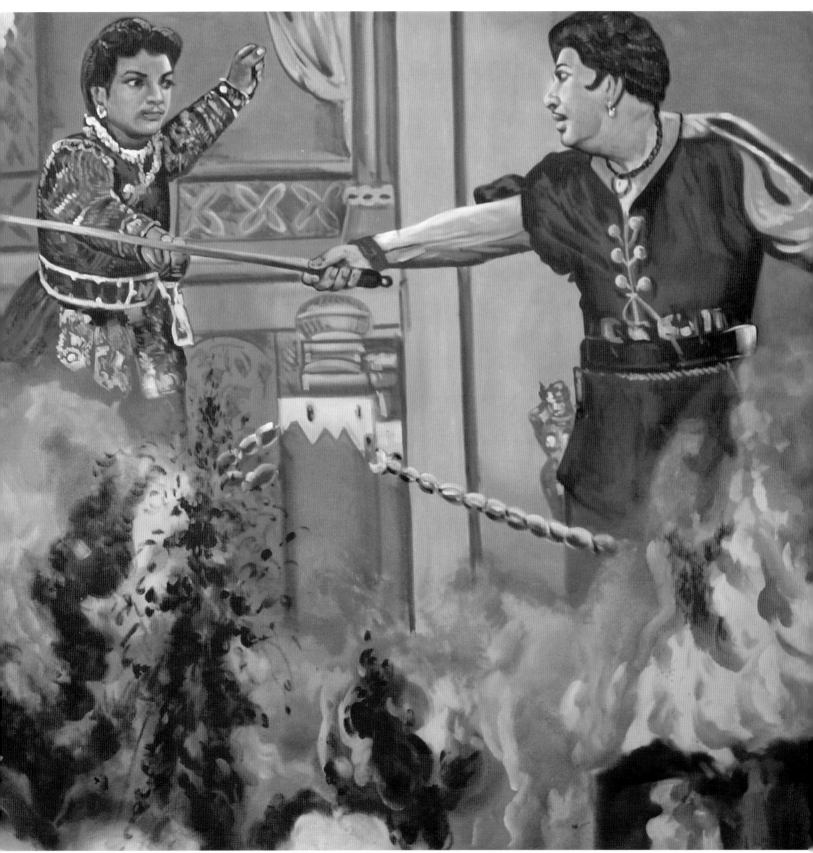

Raudhra
# The Furious

Anger, a permanent emotion, produces *raudhra* or fury. There are five types of fury, that which is caused by one's enemies – by their violating a woman's modesty, causing insult, uttering falsehood; that which is directed against one's teachers – which ought to be controlled and contrite; fury experienced in love; that directed against one's subordinates, such as servants, and finally, feigned anger.

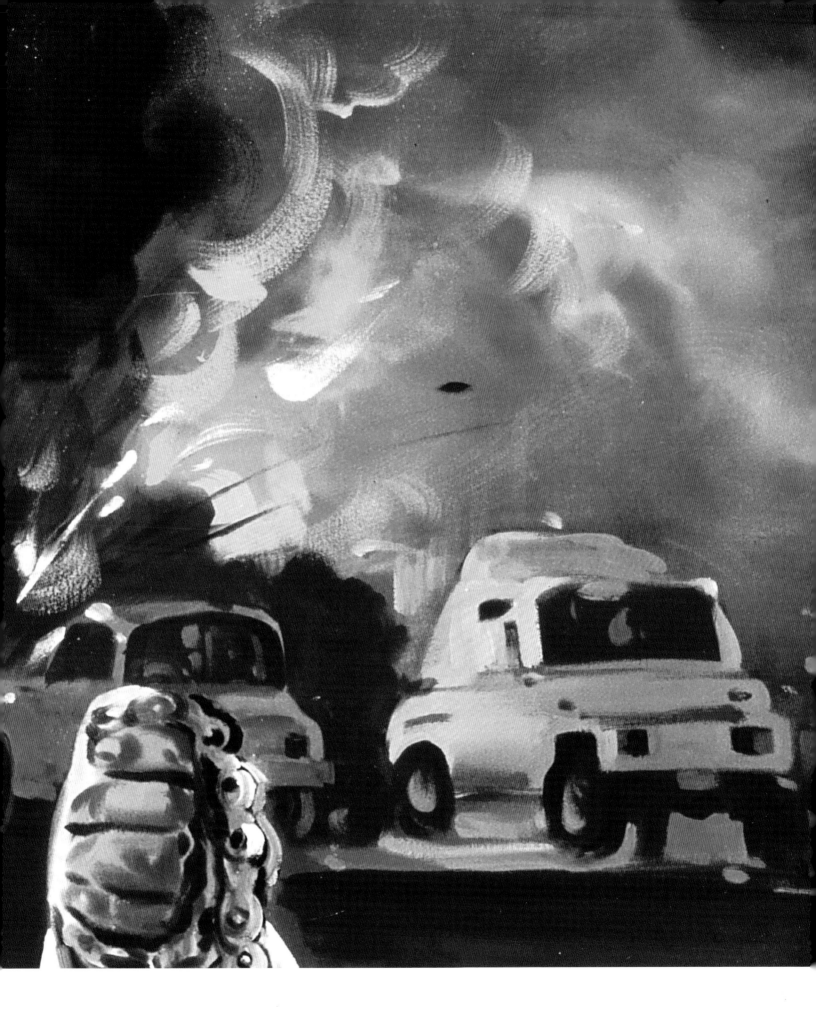

I am a sort of rascal
But I tell no lies,
I don't ask for trouble
Nor go seeking it,
I give as good as I get…
I look up to no man for my fortune,
Why, I stand tall, like the sky.

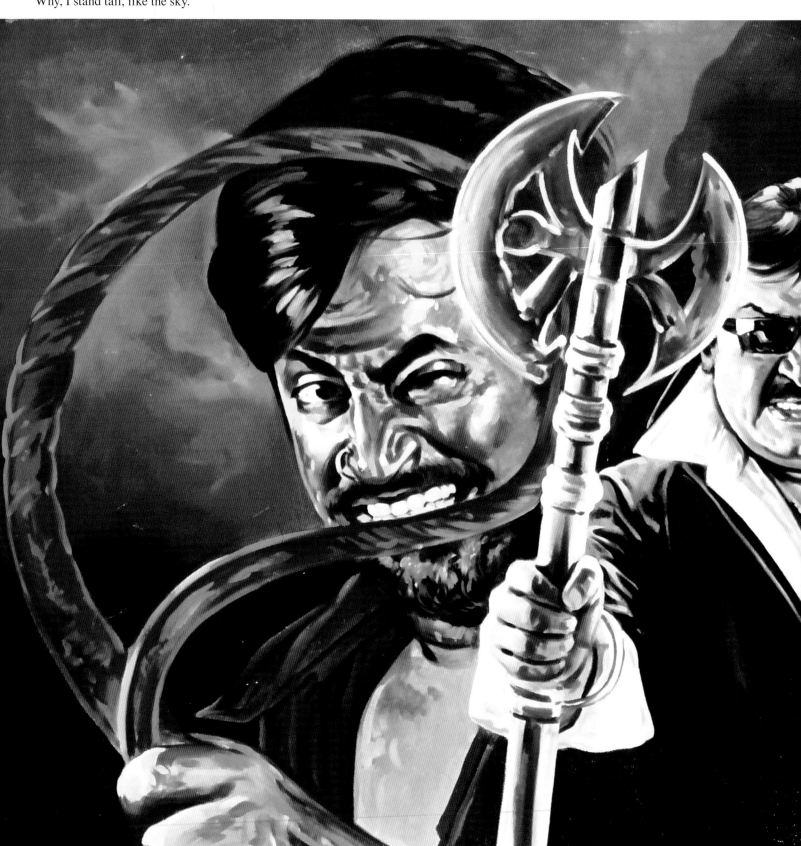

Film lyrics from *Pollathavan* (The Rascal)

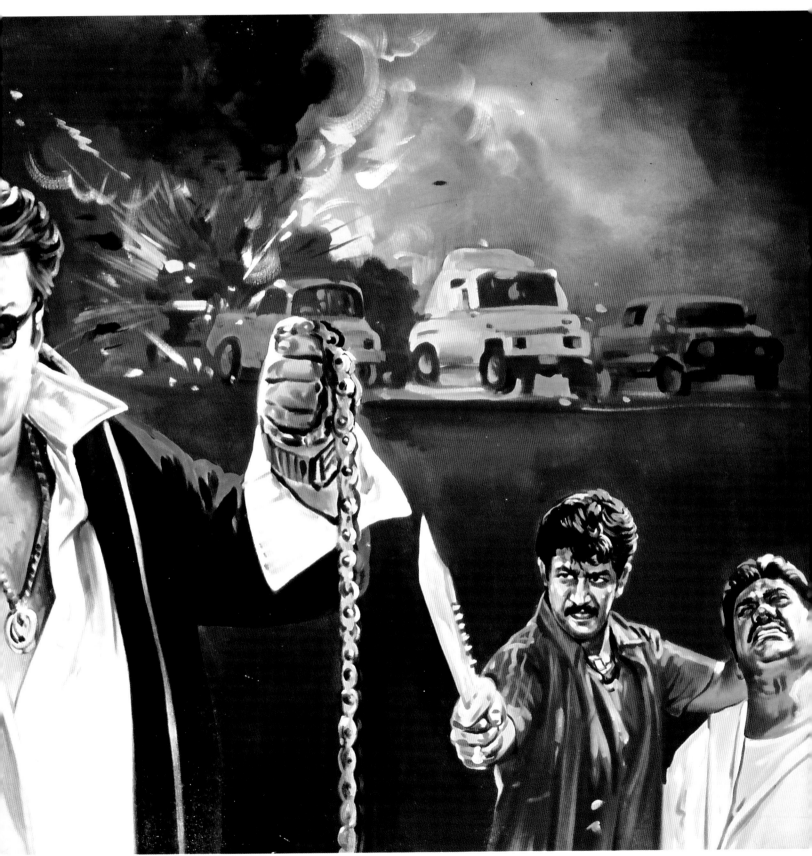

All you touch is money,
You sell food to earn money,
Or you sell your kidney,
You join a gang… for money,
You beat someone up… for money,
Didn't Judas betray Christ for money?

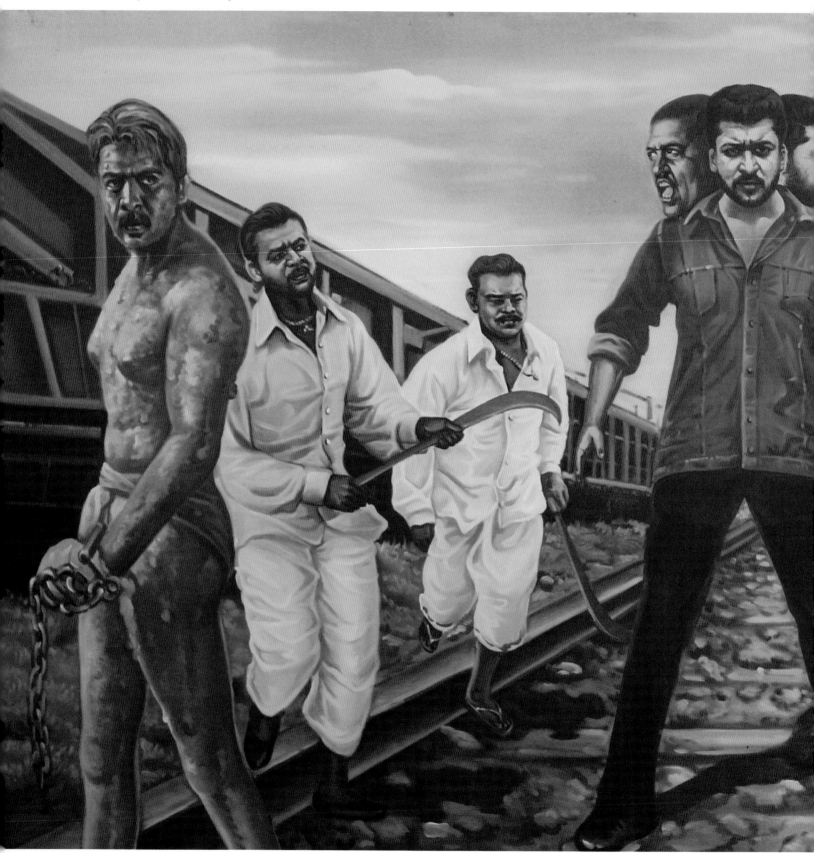

Film lyrics from *Alli Thandha Vaanam* (The Greatly Giving Sky)

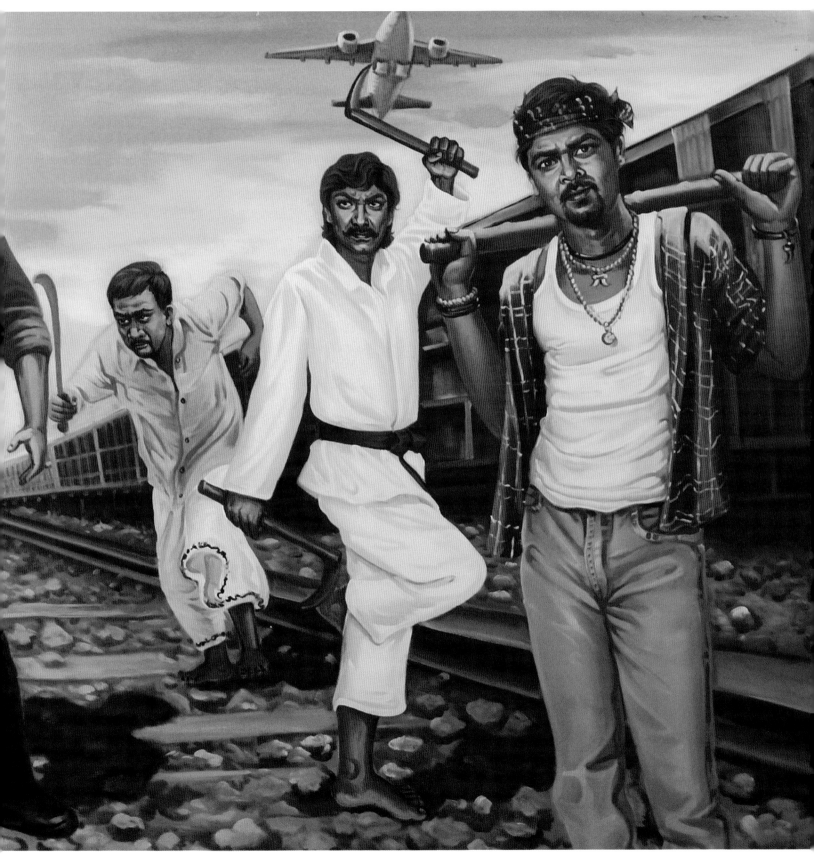

Oh here she comes,
A gentle breeze that's turned into a stormy wind,
A goddess who has dared cross the threshold,
Oh, can't you see the lines of time and good and bad are changing?

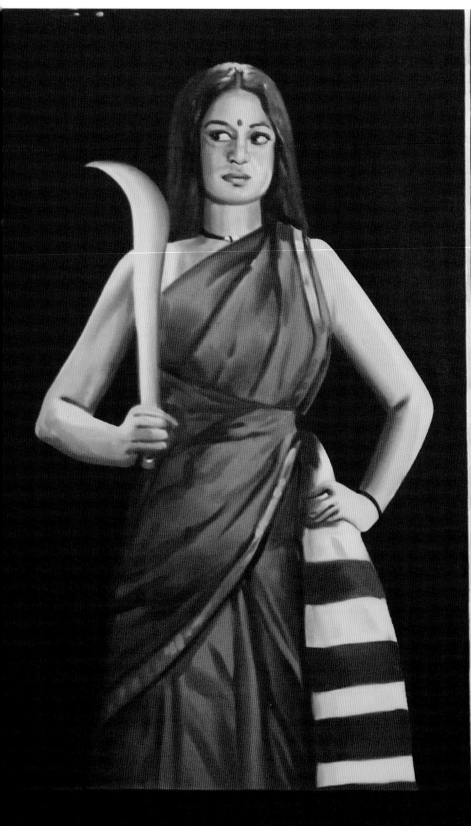
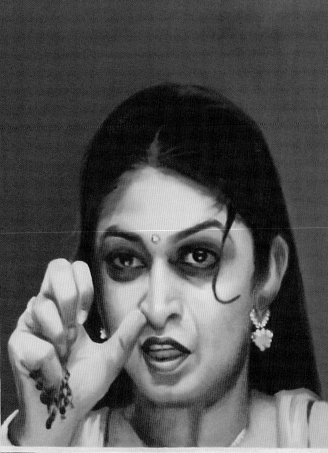

Film lyrics from *Pudumai Penn* (The New Woman)

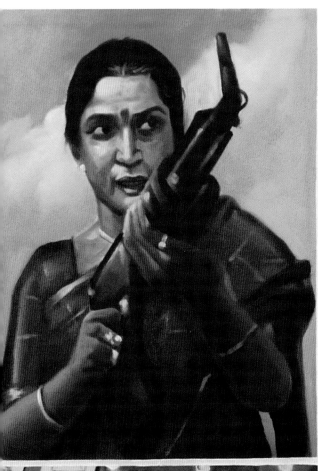

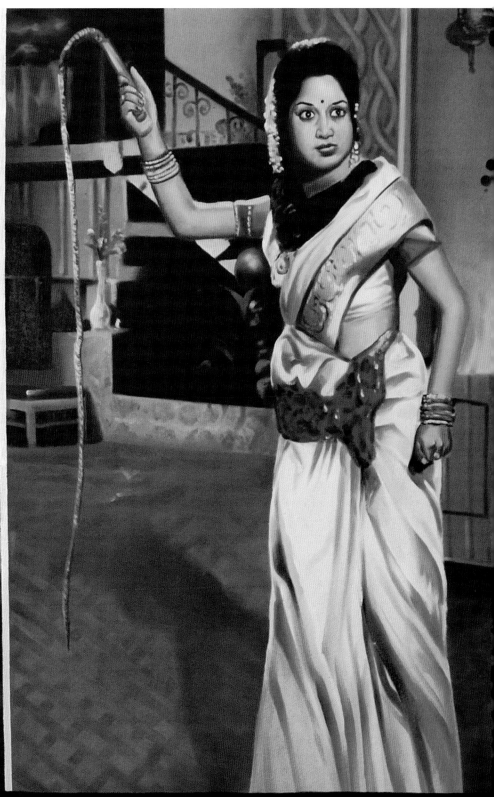

## Bhayanaka
# The Terror-stricken

Terror or *bhayanaka* is born out of the permanent mood of fear. It is experienced more by women than men. The sight of strange, cruel creatures, such as jackals and owls, a haunted house, sojourn in a secluded forest, wild landscapes, crimes committed against kings and teachers, death of dear ones and imprisonment cause terror. Even hearing of these things causes terror, trembling and stupefaction.

They whisper sweetly treacherous words
And muddle your mind,
They cast a net for you, these deceitful men
There is poison in their hearts,
That curdles the faith of those who believe them.

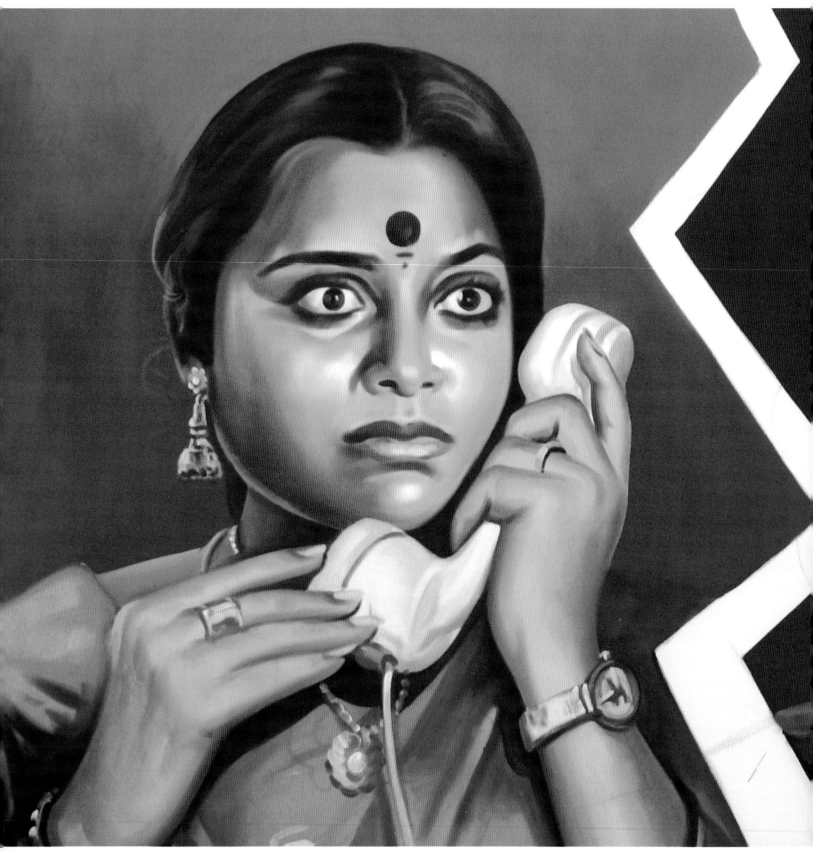

Film lyrics from *Kaithi Kannayiram* (The Convict Kannayiaram)

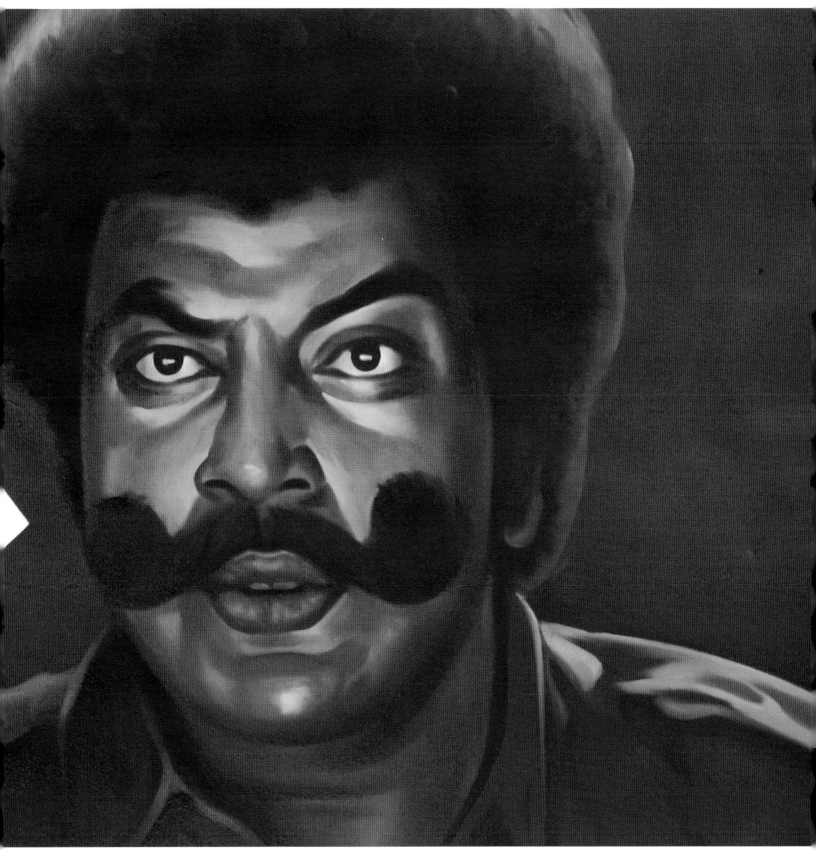

Who should this ignorant woman believe?
Oh, oh, in this world full of deceit
Who indeed can she trust?
When all intimacies prick like thorns
And all that is living turns to stone?

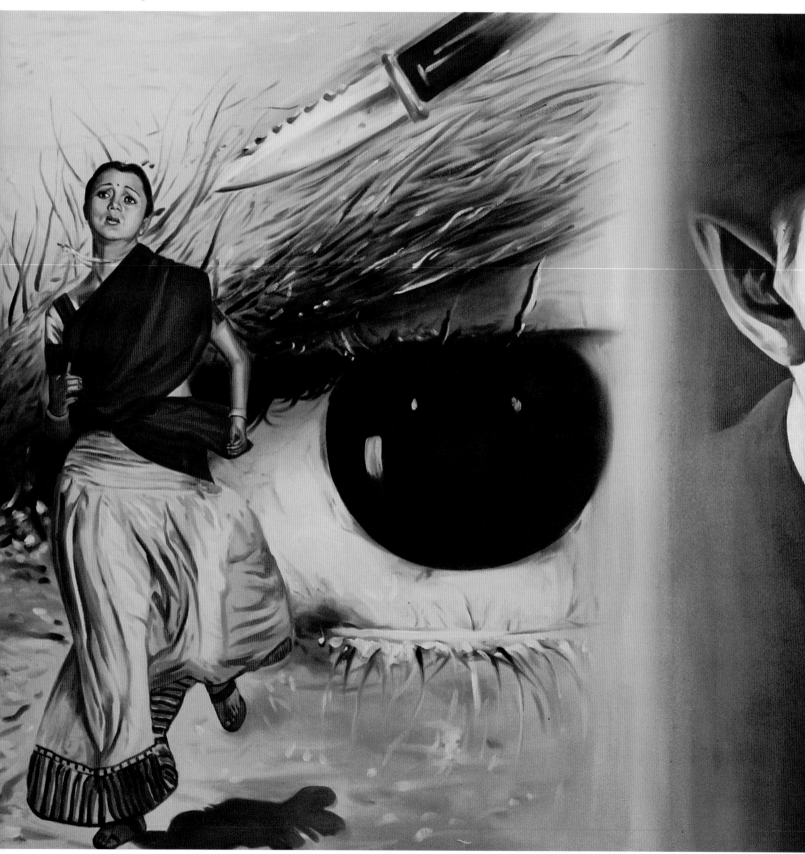

Film lyrics from *Parakkum Paavai* (The Flying Maiden)

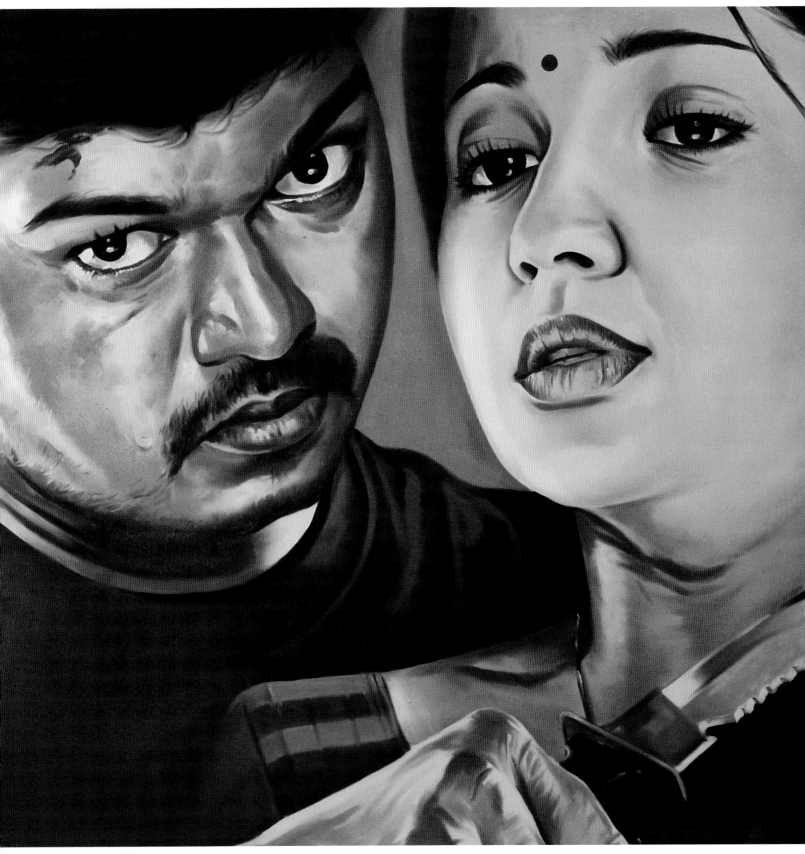

Karuna
# The Pathetic

The permanent mood of sorrow produces
pathos or *karuna*. Harsh words, separa-
tion from loved ones, on account of
a curse, loss of wealth, imprisonment,
murder and abandonment create pathos.
Associated with tears and lamentation,
pathos is aligned to fortitude in men
and expressiveness in women and other
lower types of human beings.

Why do our eyes hoard water?
So that a woman can weep time away,
Why do our hearts remember?
So that a woman can forget the deceitful.

Film lyrics from *Policekkaran Magal* (The Policeman's Daughter)

2

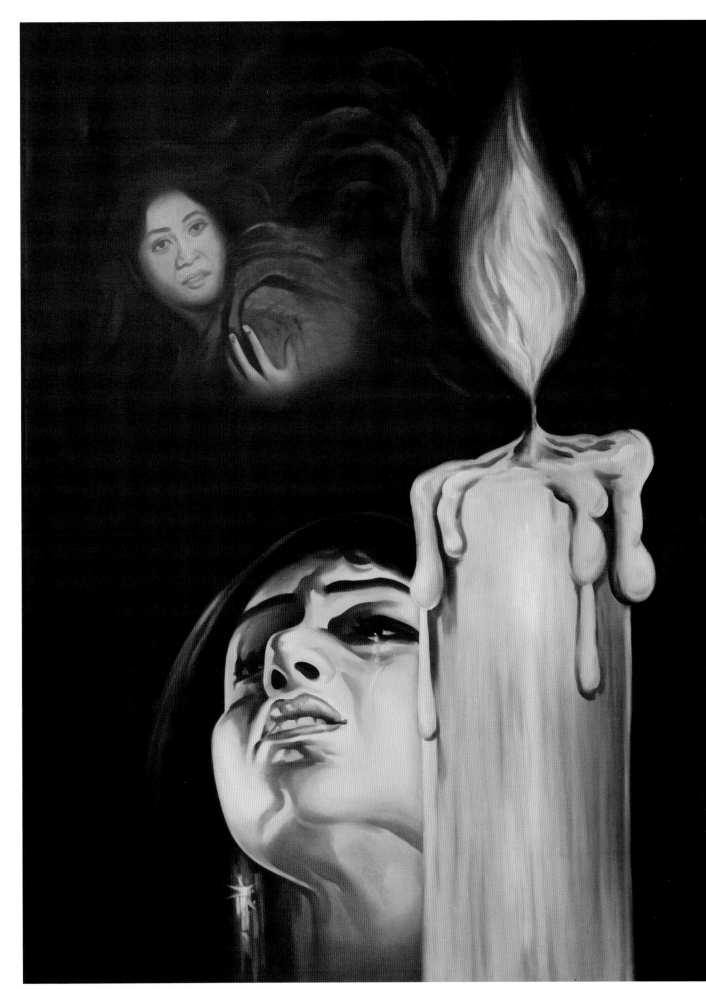

My song is a lullaby sung by a child,
A morning tune that echoes at dusk,
A dawn that flushes the west,
A boat that has lost its river…
I see a bird with broken wings in the sky,
And so I live thinking of her,
Who does not love me.

Film lyrics from *Oru Talai Ragam* (Unrequited Love)

# Hasya
# The Comic

The comic - or *hasya* - is born of the sentiment of mirth. It is caused by ludicrous imitation of another in dress, wearing ornaments that don't fit, by impudence, light-heartedness, prattling talk, satiric fault-finding and by strange and distorted gestures of the body. The comic is of two kinds. Women and children have recourse to the lower kind, which involves mocking others and laughing boisterously. Superior beings, including men who are of high birth, cause smiles and gentle laughter.

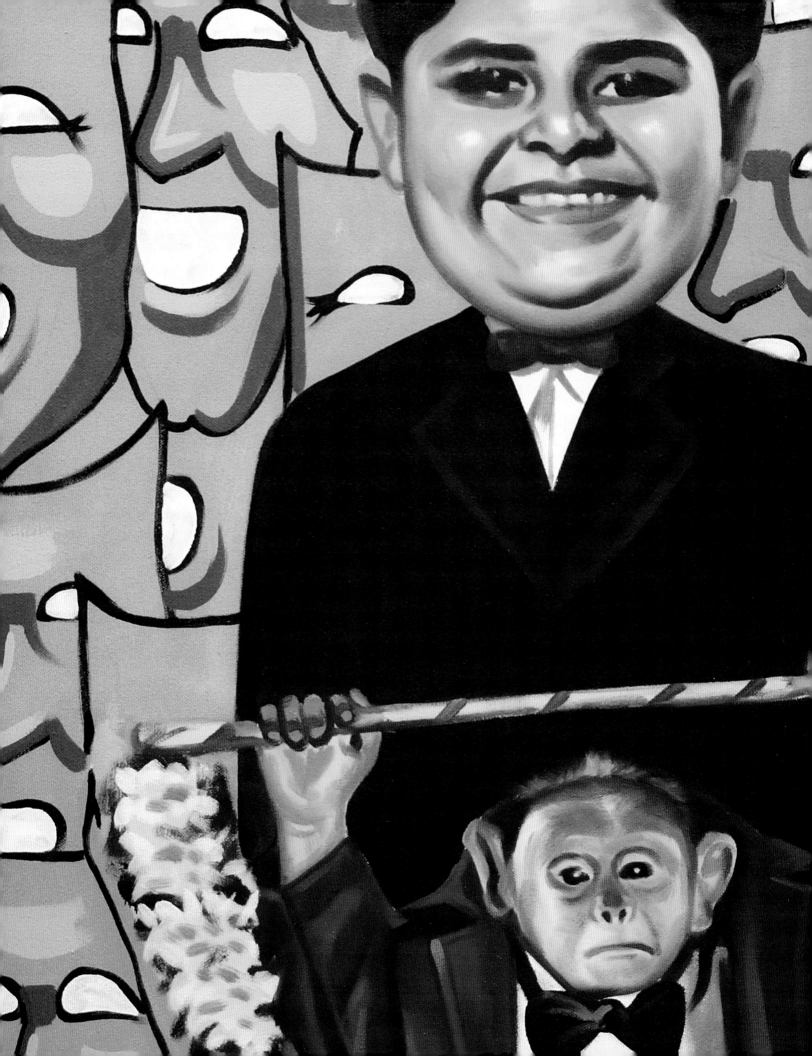

Oh, I feel like laughing,
At what the big men do,
And the small men do,
On stage their talk flows like a river,
Off it, all is forgotten forever,
Why bother? All you need is to open your purse-strings,
And even a donkey could be commanded to sing.

Film lyrics from *Aandavan Kattalai* (God's Command)

A lamb laid eggs and hatched chicks,
It was the elephant calf that told me this…
Believe me, this is not a far-fetched tale,
Such things happen in this world,
And not only this, good people,
There are other funny tales to tell…

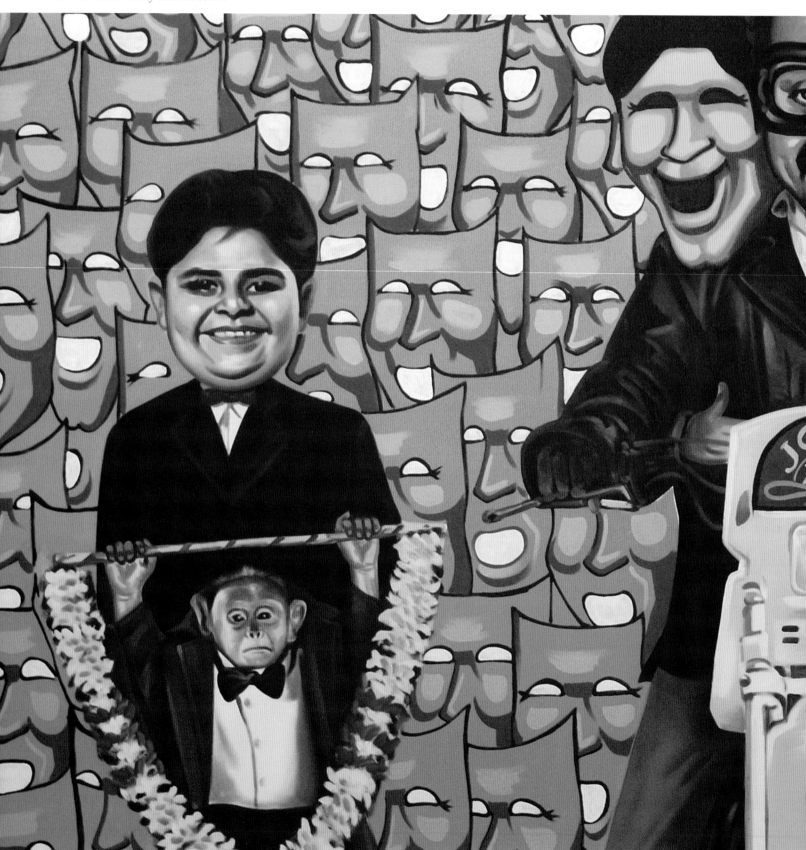

Film lyrics from *Pathinaaru Vayathinile* (Turning Sixteen)

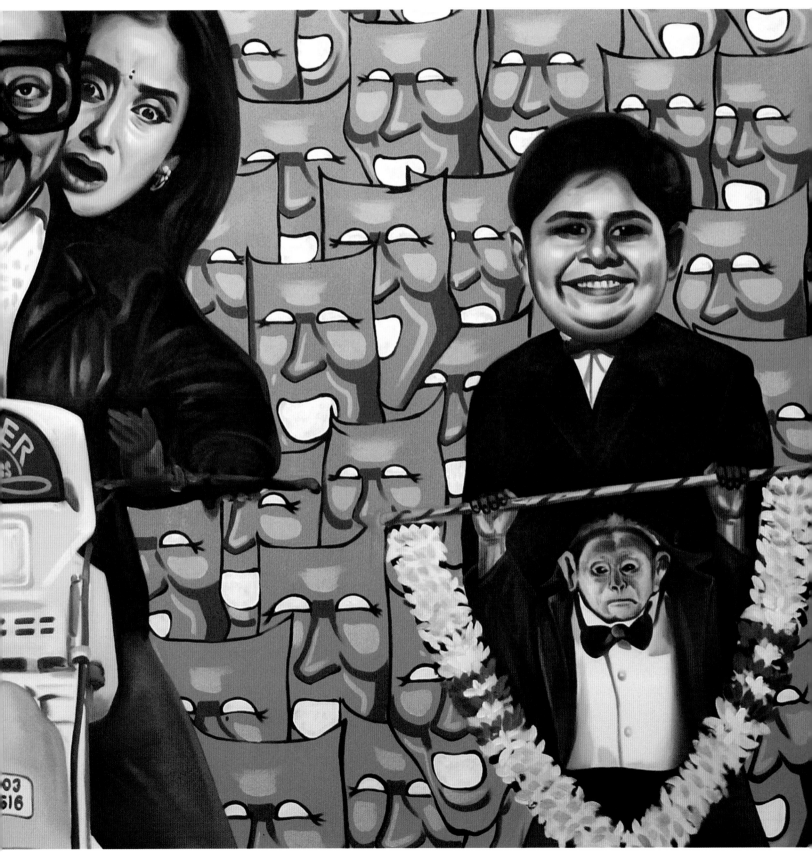

Bibhatsa
# The Disgusting

The permanent mood of aversion produces *bibhatsa* or disgust. Seeing and hearing things that displease, cause disgust and which defile one's person, even knowing of them cause disgust. Disgust is felt physically – as foul smell, bad taste and tainted touch.

It is a blind world that takes its chances
By following the narrow criminal path,
Oh, brother this is a world that shows its prowess
In lying and cheating.

Oh brother, this is a world that chooses to
Clothe its reason with darkness,
And resort to endless fights,
A world that is rough and raw.

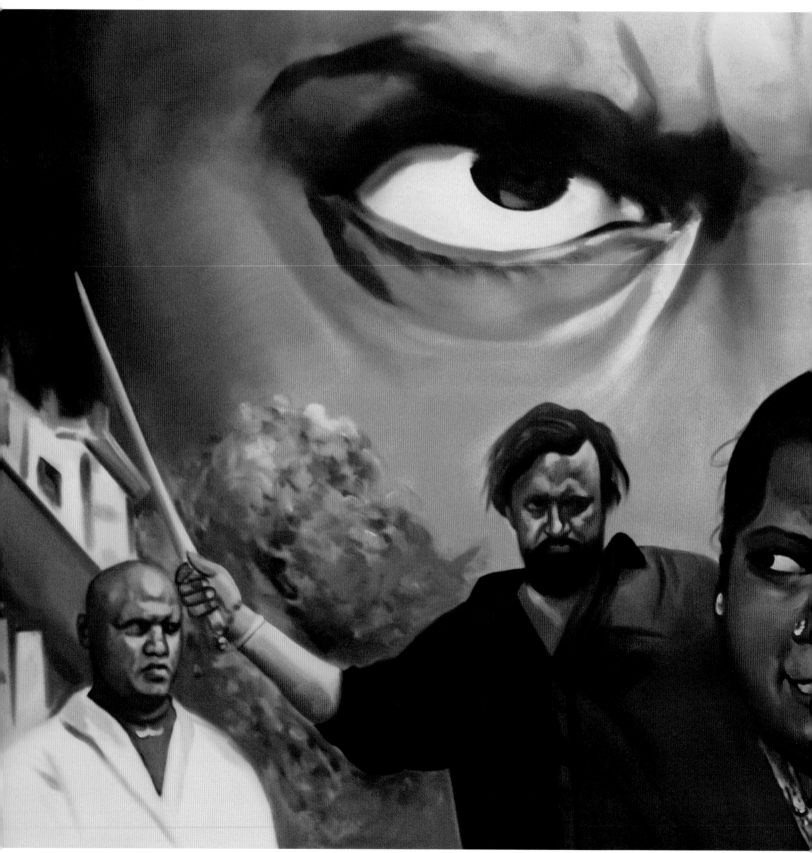

Film lyrics from *Mahadevi*

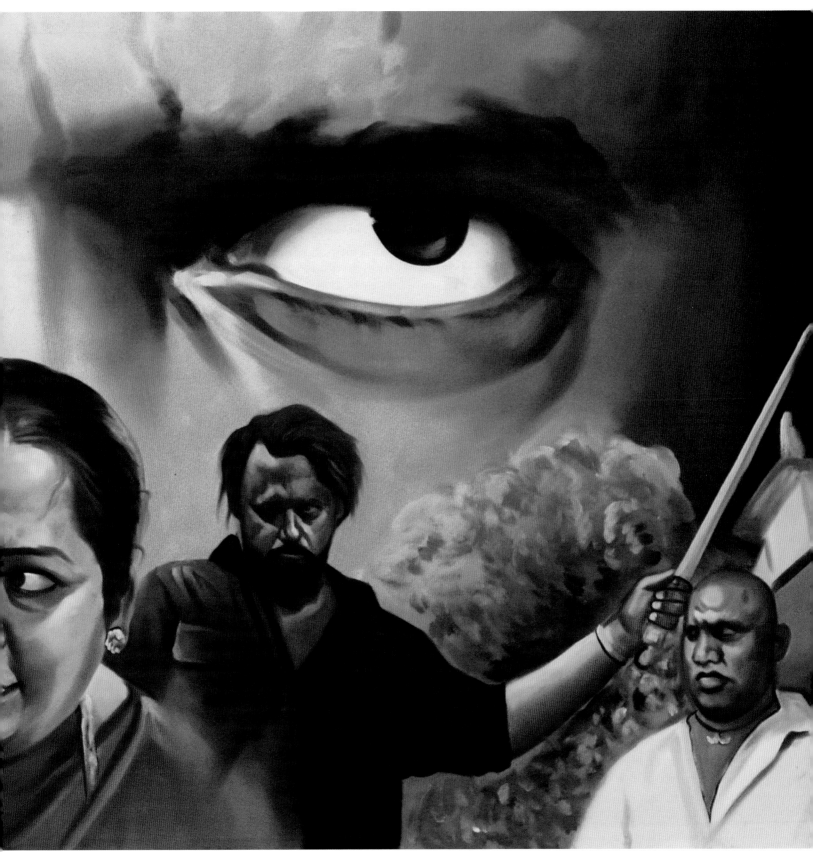

Adbuta
# The Marvellous

A sense of wonder gives rise to a sense of the marvellous, or *adbuta*. The sight of celestial beings, beautiful palaces and towers, even of illusory things, wandering in a pleasure garden, going to a temple, words and craft that are beautiful – all these induce a sense of wonder and marvel.

We want a new Earth every day,
And a new sky to go with it,
We want it to rain gold everyday,
And still the koel must sing,
Sing on in our Tamil tongue.

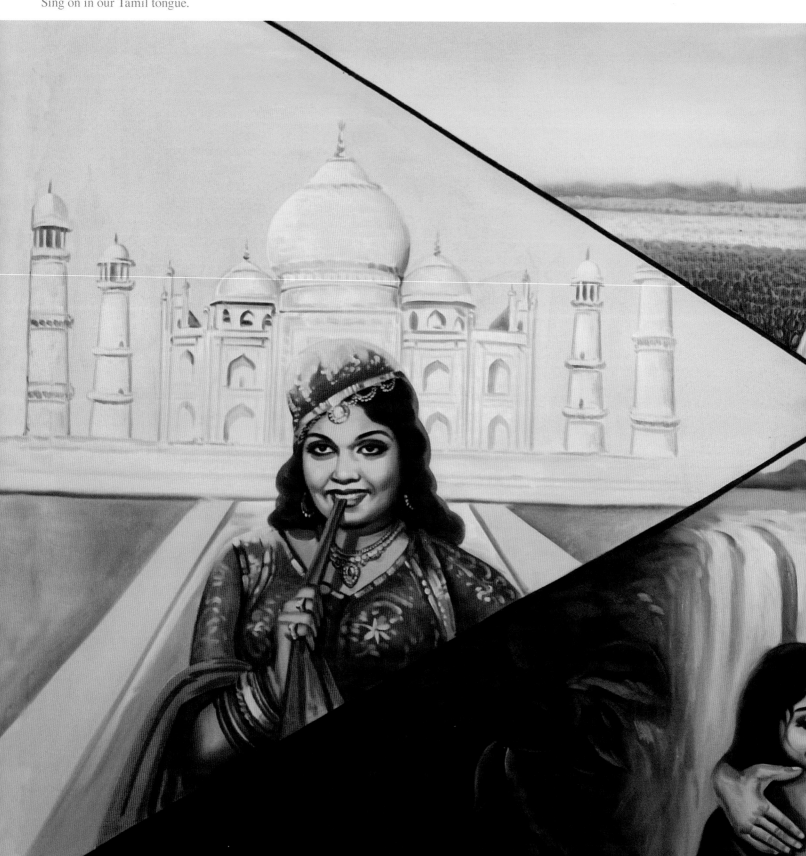

Film lyrics from *Thiruda, Thiruda* (Thief! Thief!)

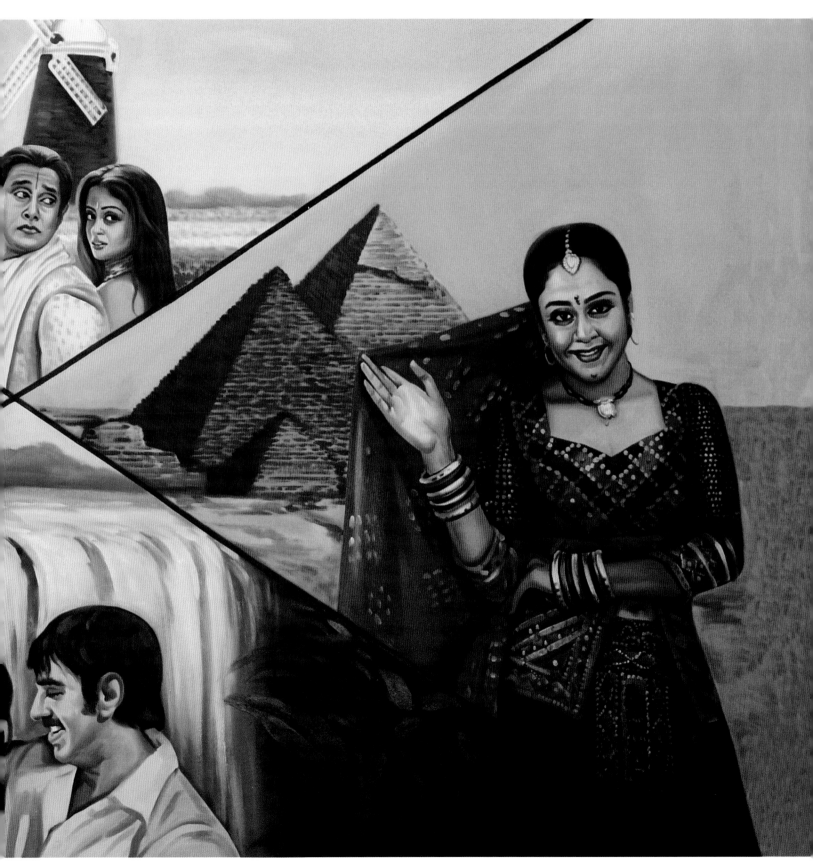

Eyes, eyes! Look!
Isn't she the Mafia
That stole my heart?
Or the Capuccino coffee-ah
That delights it?
Oh, my Sophia,
Oh, my Apple laptop girl…

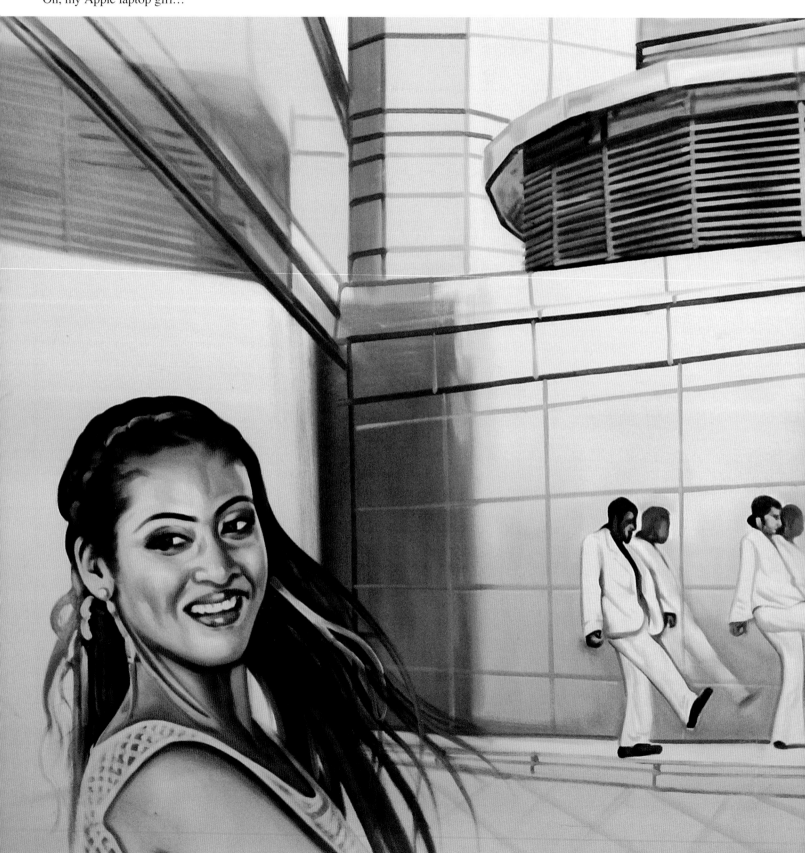

Film lyrics from *Anniyan* (The Stranger)

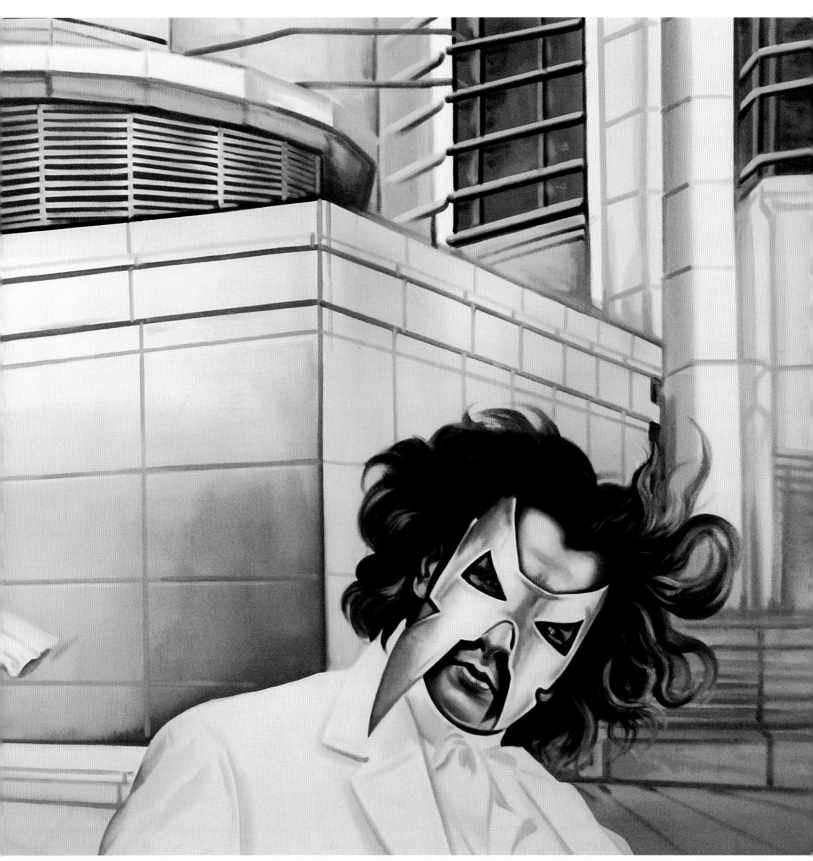

Shanta
# The Peaceful

*Shanta* or quiet ensues from the permanent mood that is tranquility. Freedom from worldly desire, purity of heart and knowledge of reality…meditation on the supreme spirit, compassion to all spirits, a spirit of equanimity – these produce peace.

From *Natyashastra*

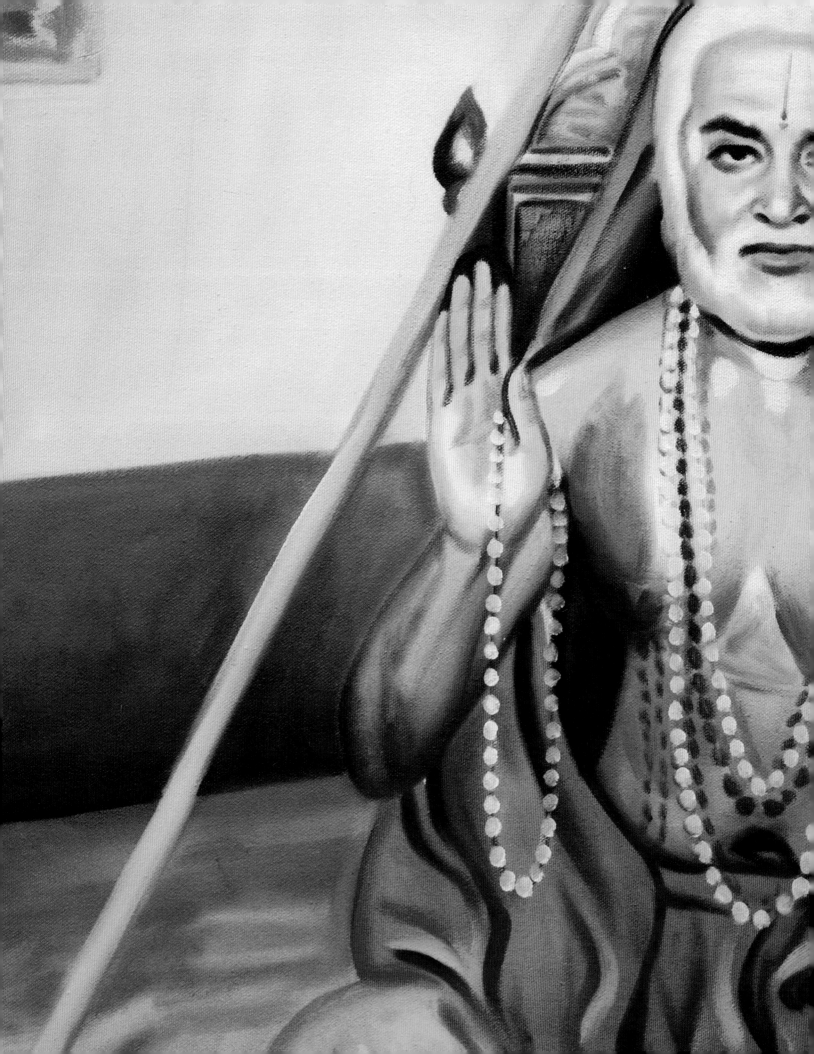

Those who believe are never betrayed,
This is what the four scriptures hold,
God is ever on the side of the meek, the poor
**Oh, come to Him, unhappy heart,**
Who is a feast to the hungry,
A cure that heals the sick,
**Come and seek your peace here.**

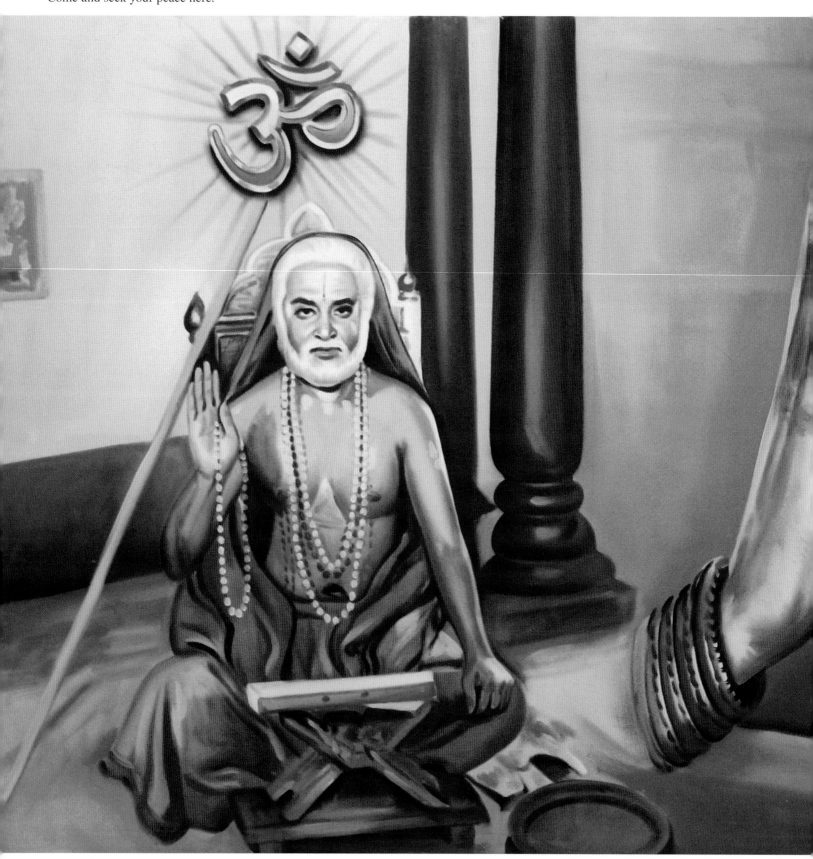

Film lyrics from *Ramu*

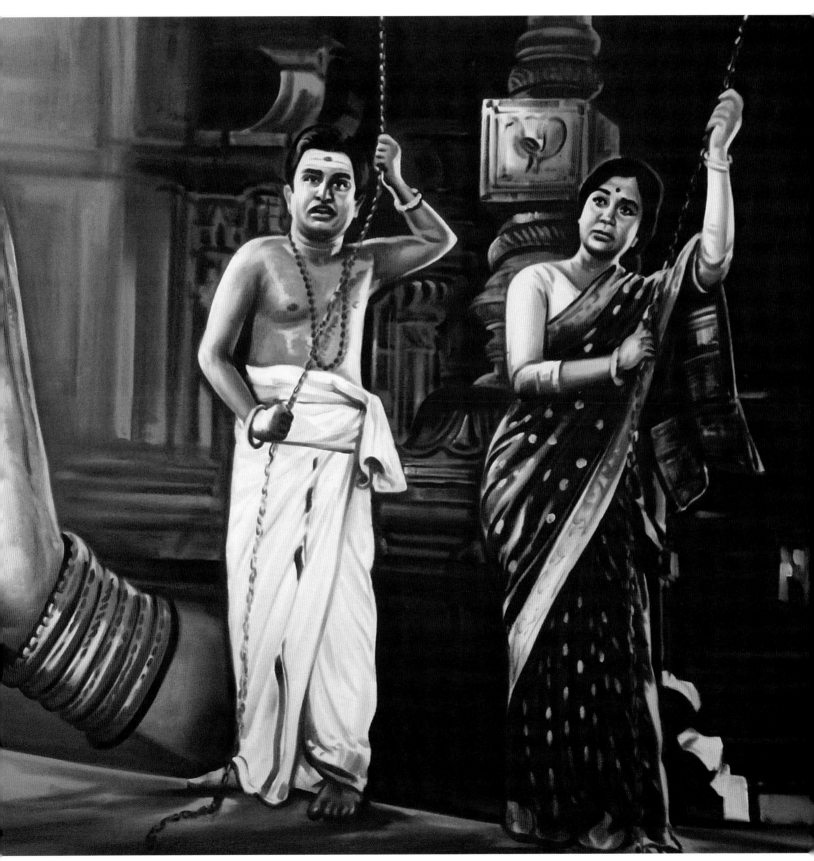

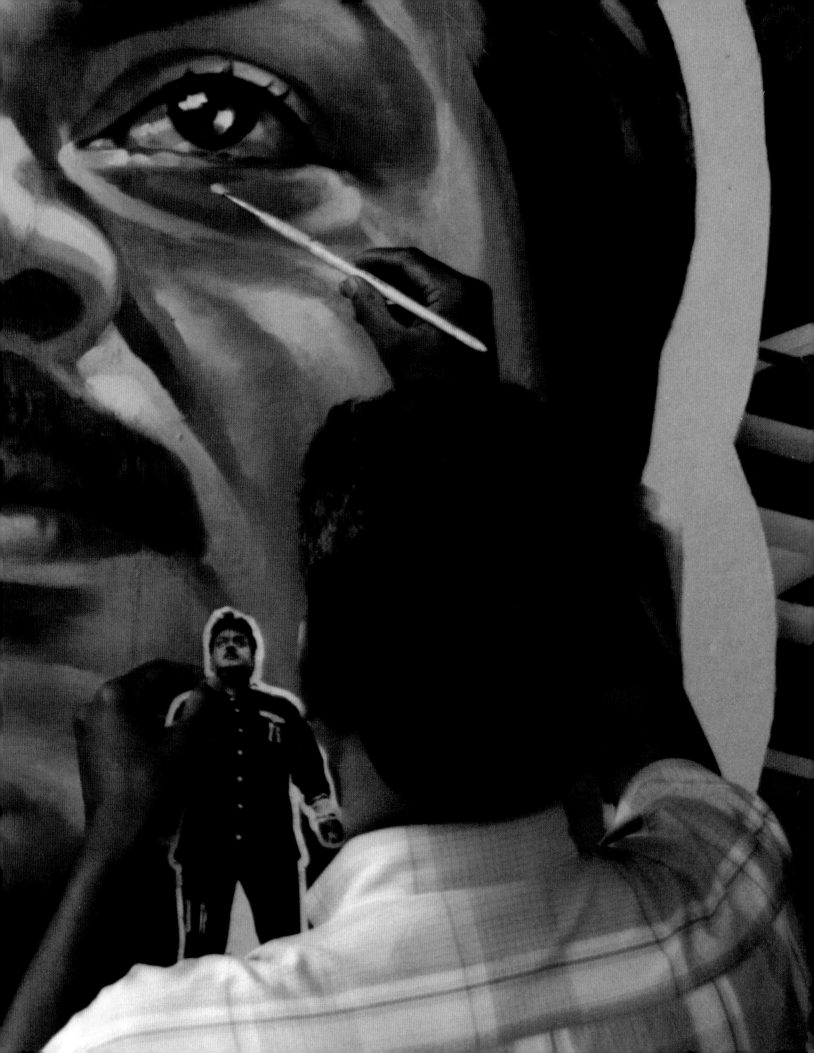

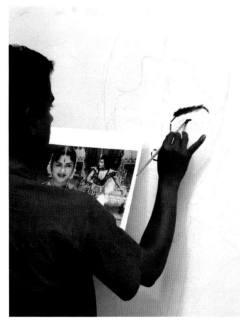 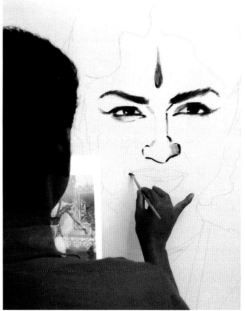 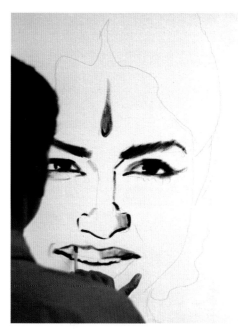
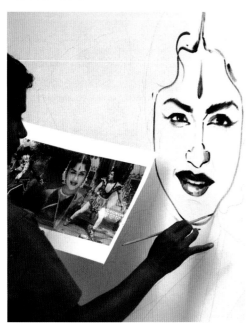 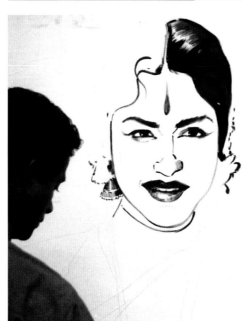 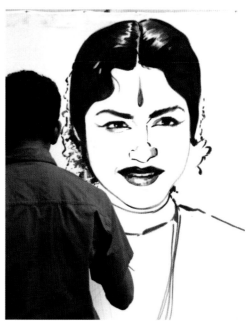
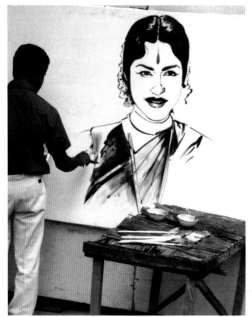 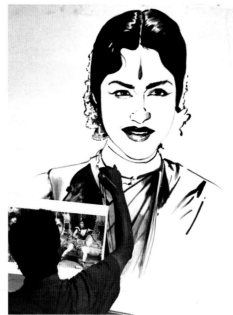 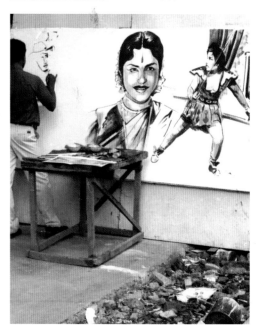

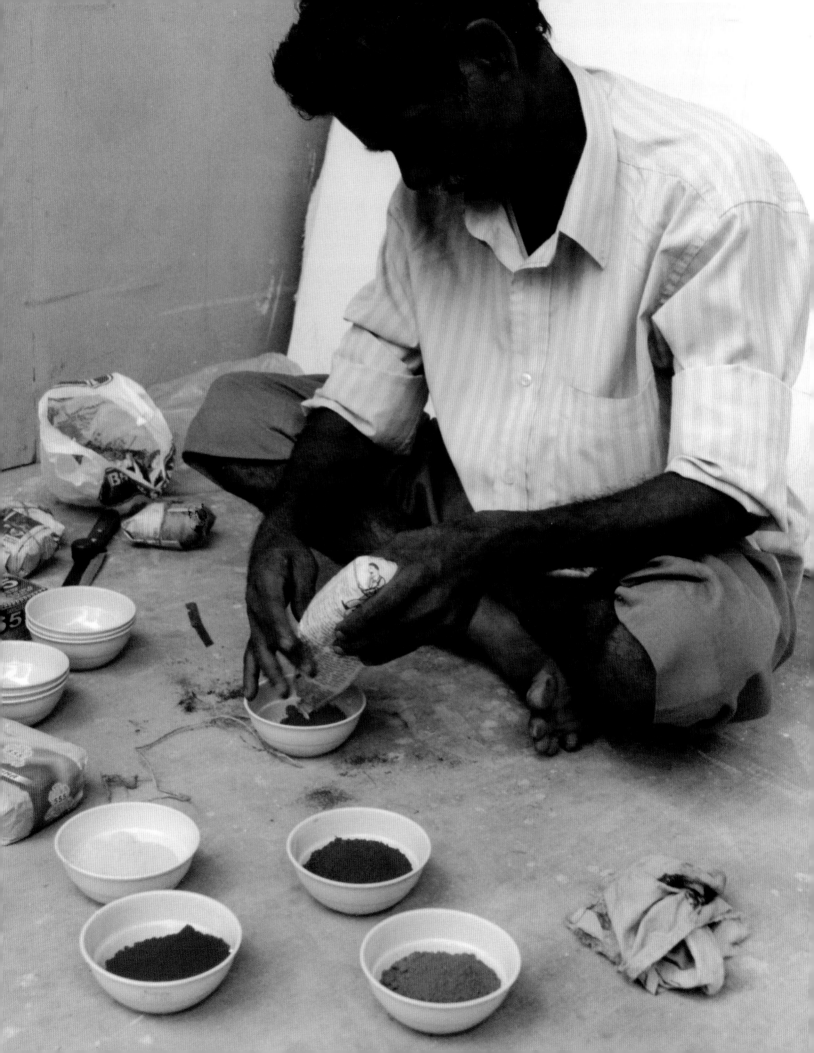

# Towards a Grammar of Expression

The Nine Emotions
The erotic, the valorous, the furious, the terror-stricken, the pathetic, the comic, the disgusting, the marvellous, the peaceful. Each of the nine emotions portrayed in this book is a piece of fiction, inspired by cinema hoardings art, especially its ability to produce a concentrated image, sentiment, tale and moral. Memory and imagination inform this fictional engagement: a remembered sense of how hoardings looked in the past decades, as well as a playful sense of how characteristic film motifs and symbols could be arranged to stage a singular emotion helped produce these images.

These painted emotions aspire to a generic status both conceptually and visually. They invoke the distinctive art of Tamil cinema, and simultaneously gesture towards a larger aesthetic whose tenets, inform, both consciously and tacitly, a variety of art and performance forms in the Indian context. *Natyashastra* an authoritative Sanskrit text, written in the second century C.E. affords an enabling entry into this complex and layered aesthetic and helps notate the art that sustains these paintings.

A Theory of Aesthetic Competence
*Natyashastra* is eloquent on the subject of the emotions. It proposes a theory of representation that considers the emotions central to human experience, but goes on to argue that they are not merely subjective or pertaining to the individual self. The text distinguishes a 'permanent' emotion or *sthaayibhava*, as human beings experience it or as it is present in a subjective consciousness, from how that emotion is expressed in art and literature. It notes that the emotion

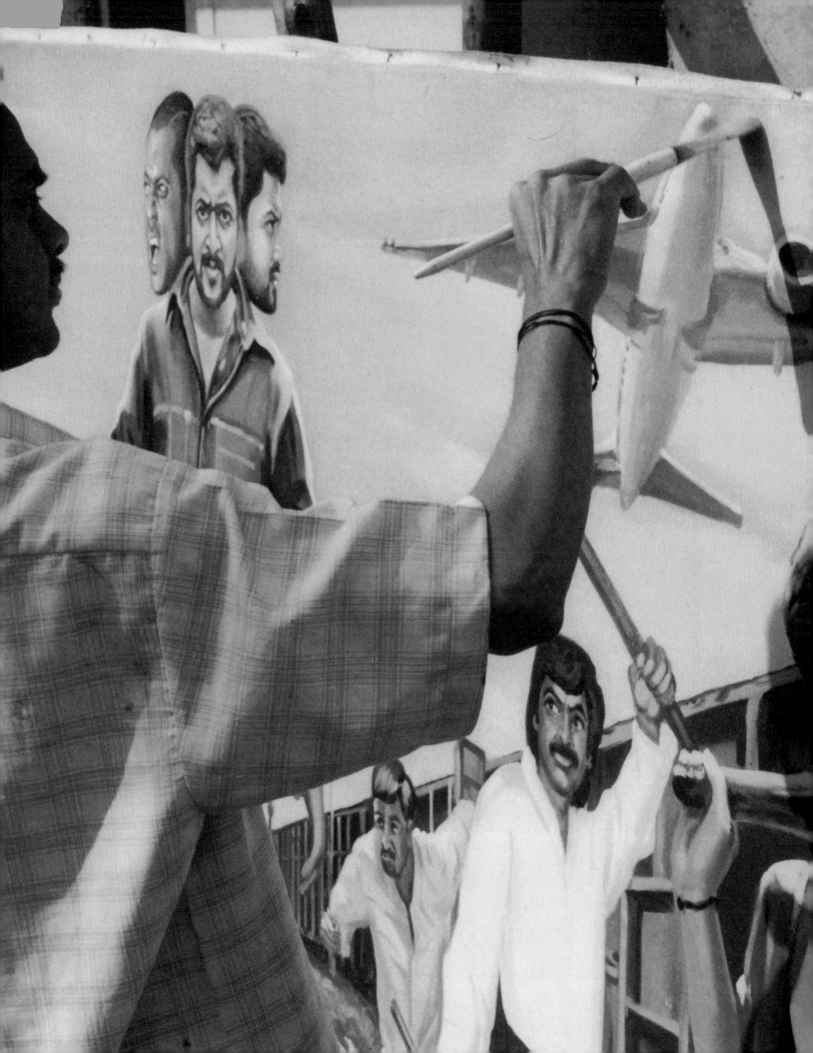

that is a feature of a work of art exists more as an aspect of character and plot, than authorialintention. Further, the represented emotion seeks to communicate itself, in all its aesthetic self-consciousness or *rasa*, and not its 'real,' 'worldly' correlate. It seeks to do this artfully through recourse to convention and symbolism. Art and performance, *Natyashastra* makes clear, do not owe their efforts to acts of mimesis. There is a public language, a learnt aesthetic competence that sustains art as a system – of motifs, signs, icons – which is understood by the creators as well as their audience.

Interestingly, *Natyashastra* employs a culinary metaphor to describe the aesthetic process. It notes that just as one blends spices to garnish a meal, a superior work of art subtly blends together different emotions. It further argues that the result of such a blending must necessarily be different from the taste of each individual ingredient. Thus a work of art, it implies, ought to be uniquely flavoured, with one or perhaps two emotions defining its character and theme.

The all-important question is: what sustains this blending? *Natyashastra* appears to suggest that there is an aesthetic alchemy at work, which transforms the emotion into its aesthetic correlate, sthaayibhava into rasa. The details of this alchemical process vary: comprising conventions and tropes, traditions of rendering and performance, as well as historical and contingent influences which frame and direct the process.

Emotions and Their Tropes

As far as popular culture, including cinema, is concerned, the so-called real world and its concerns are repeatedly mediated through a rich mix of immutable traditions and contextual imperatives. This gesture is repeated in the hoardings as well: a veritable grammar of representation helps convey the charge of a particular film, the genre to which it belongs as well as its ineffable uniqueness. Importantly, this grammar works on the emotions, for these, for a substantial part, constitute genre: anger and valour are central to the action film; the erotic and a sense of wonder pervade romances; sorrow and fear as well as the socially disgusting are evoked in family and social films. Humour is an all-pervasive emotion – which lightens the tough anger of the hero's grimace, leavens the sentimental affectedness of a romance, and redeems the unrelenting evil of what is clearly a source of terror and disgust.

Inspired by the art of the hoarding, these painted emotions too have recourse to a public language of expressions. This appears a local argot, yet its visual energy is such that it is vastly accessible. The content of this language is given by cinema, its history, the contingent moment of a film's release, and by public memory, by the rich reciprocities that creators and

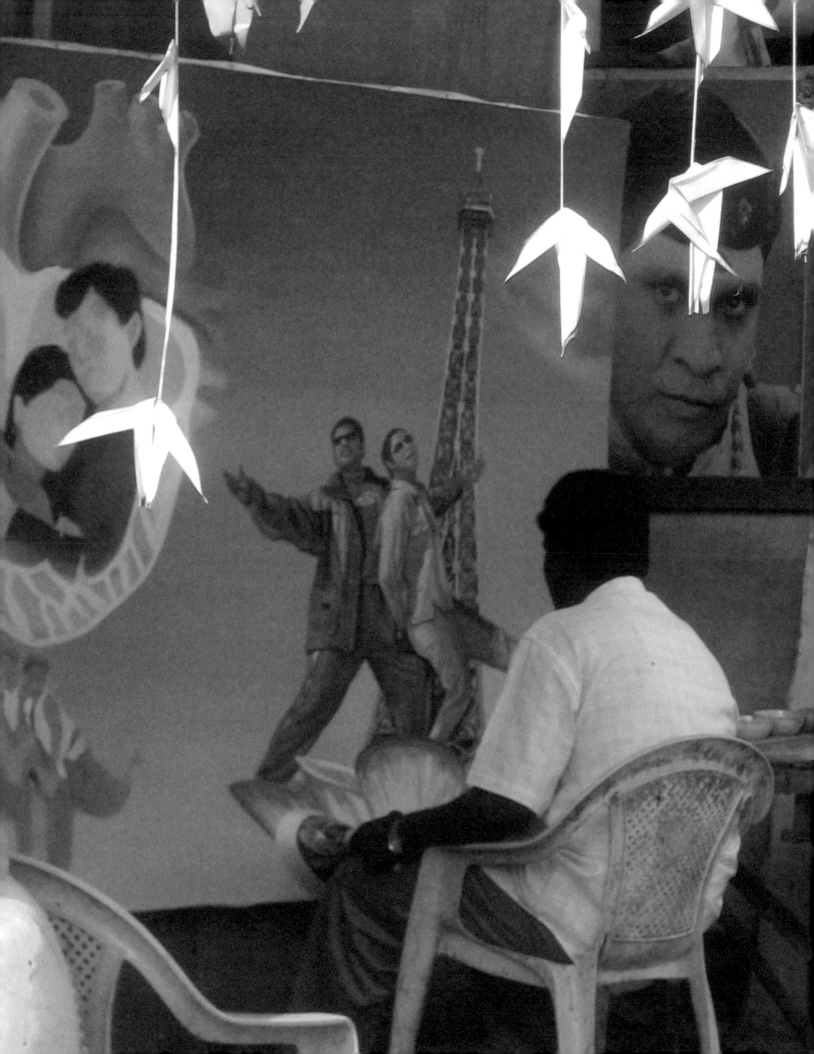

their audience share. Each emotion comes endowed with a characteristic visual resonance and an identifiable genealogy.

The icons and idioms that convey a sense of the erotic are drawn from a repertoire of film images, which, over time, has served to express its salience. This rich imagery of love, in turn, is derived from a multitude of sources, including classical Tamil literature, medieval sculpture and late colonial – and Victorian – ideas about sexual decorum.

Valour is less a celebration of a particular style of heroism and more a stylised rendering of what it takes to be valorous. This includes sporting a characteristic deportment and a display of generalised gallantry, made familiar through the action film. Images of valour in the Tamil action film, and consequently the hoardings, werc in turn influenced by Hollywood symbolism, especially the kind found in historical movies and westerns in the 1950s and 1960s, as they were by folk tales of subaltern heroes.

Anger, which is closely related to the heroic principle, has a more complex genealogy. On the one hand, it is universal in its connotations. Like heroes elsewhere, the angry hero of Tamil cinema stands in for a moral archetype, and one that is found in several unequal and unjust social contexts: as if he represented a collective desire for justice, and an enabling social fantasy. But within the history of Tamil films, these angry figures belong to the late 1970s, which witnessed the emergence of the anti-hero. Played initially by a man who wore his underclass origins plainly, the anti-hero soon acquired the aura associated with former action heroes, though his methods were less honourable. He soon spawned an entire type of both amiable and aggressive malcontents who came to stand in for social justice. The angry woman has two faces: the wronged woman who takes to revenge – an old literary and folk trope – and the arrogant woman whose thwarted pride and cold beauty make her take to arms to settle private vendettas. In both instances, anger is writ large on her femininity.

Another emotion, which connotes power, but induces disgust, is the feeling of repugnance. A response to evil and darkness, disgust in Tamil cinema is a function of human villainy. The villain, for his part, is a marked man: he wears his wrongness visibly and even exhibits it with pride. Disgust too has its associative symbols, drawn from representations of screen villainy over the decades – and which invariably have to do with a certain contortion of the face and body.

It is not only these charged, powerful emotions that are painted this way. The more mellow, retreating ones also take their meanings from a system of well-honed symbols. Thus sorrow is not merely personal grief – it partakes of the pathos of living and loving, and courts the visual

metaphors of loss, suffering and decay. It traces itself through an entire gamut of grief, ranging from a sense of personal loss, caused by unrequited or misunderstood love to metaphysical despair. The sorrowing, self-sacrificing heroine, whose tear-stained face and wasted body and limpid eyes have helped convey sorrow to generations of film goers in the Tamil country is her own symbolism; but she also exists amidst objective correlates – a dripping candle, a wasted tree, a broken pot and so on. The despairing hero who has lost out in love is also a staple of Tamil cinema and recognisable by his unkempt beard and soft eyes filled with longing. Often, his sorrow turns to metaphysical distress and is signified through his taking to drink, madness, flight and death.

Terror, linked to sorrow, but also to disgust and anger, both of which cause it, seeks to embody its sense of hapless fear through recognisable expressions of vulnerability. The flight from horror, violence, evil or even from rough love – which heroines over the decades have perfected – serves as a fit expression of fear that is almost always a gendered emotion in Tamil cinema.

The comic, caused by a concatenation of impossible situations, wordplay and derisive laughter, induces humour. It is hard to portray, since humour is intensely contextual and cultural. Exaggerated expressions are usually associated with the comic in Tamil cinema, as are odd clothes, masks and disguises. These transform into given conventions of representation, which have to do with size, composition and the mixing and (mis)matching of elements in a painting.

Wonder, likewise, is inexorably cultural, since the sense of the marvellous that it provokes is dependent on what a society considers exotic and fantastic. However, in visual terms, the marvellous is instantly knowable in the world of Tamil film – as a feature of landscape, monuments and costume.

The ninth and last emotion, peace, is hardest to express in the context of Tamil cinema grammar, since it goes against the grain of this energetic and raucous art form. Yet, in a richly religious culture, there exist symbols and gestures that achieve peace for the viewer: temple bells, praying hands, gurus...

The grammar of expressions that may be gleaned off these paintings offers its own gloss on the arguments presented in *Natyashastra*. This does not mean that there is a seamless continuity between the second century and the present. Rather that in some cultural contexts, art may not at all be about a cognitive engagement with reality, but may be about something else, as in our instance, where representation has as much to do with pleasure as with context and meaning.

Producing Pleasure
# Hoardings in Context

## Origins

A film hoarding is inexorably commercial in origin. It is usually commissioned either by the producer of the film in question, or those who have acquired rights to distribute it. Sometimes an actor or admirers of an actor – his or her 'fan associations' – are also known to commission hoardings. The hoarding precedes the film and affords a synoptic public preview of the new offering. Producers seek to impress and lure distributors with it, and distributors, the public.

The first step in commissioning a hoarding is to identify a studio or a group of artists whose talents would work best for the film at hand. The publicity desks of production companies could be relied upon to identify such artists – or rarely, the producer himself might know of artists he had worked with in the past and recall them for the present purpose. Once an artist and his studio have been found, they are presented with stills from the film, along with an explanatory note on its plot and characterisation. This is also done in the course of conversations between the producer or distributor and the artist.

The artist and his group then begin work on the stills: they cut, edit and assemble the images from the stills into mock-ups of the hoardings they would eventually paint. They work partly to convention, relying on previous hoardings on the same theme, or those featuring the same actors. But they also seek to provoke attention and so think up a novelty or two that would make their hoarding capture the public imagination. Once the mock-up is approved – sometimes the producer or distributor might add or delete a detail – the artists begin work.

'In the early days, they used to scale up from a postcard-sized visual to an 8 x 16 foot hoarding by using a grid. You basically divide up the postcard, and then replicate the same grid onto the canvas using a string dipped in coloured chalk. Then every section of the grid is copied on the hoarding. Nowadays it's a bit easier – we trace the image out on a glass plate and project the outlines onto the canvas using a backlight.'
– Dhakshna

'The problem with projecting from a glass tracing though is that we have to wait for nightfall – usually midnight so that it's really dark. Because we work outside on the street, we need to keep away from street lamps or any other source of light. One of us holds the spotlight behind the glass and the other traces the outlines out onto the canvas, and so we have our scaled up drawing. Then it's only a matter of filling the outlines in, which we tend to do freehand.'
– Dhakshna

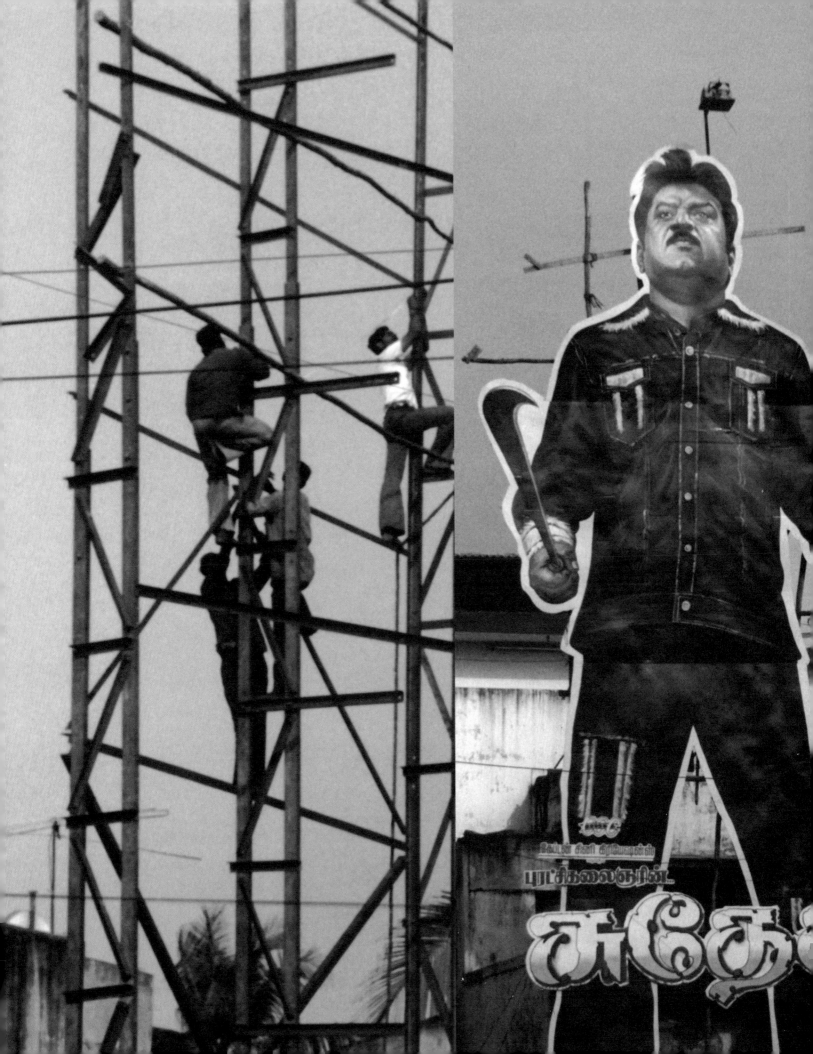

## The Making of a Hoarding

Before beginning work, the chief artist has to assemble his 'team': this includes the carpenter who prepares the frame to which the canvas is nailed; the artists who would assist him with completing the hoardings; the workers who would eventually transport the finished hoardings to their destination, and finally the group that is responsible for the scaffolding that has to be erected to get the hoardings into place.

The carpenter begins work first and prepares the frame to which the canvas is nailed. The canvas is usually a large piece of coarse cream cloth – or *gaada*, as it is called – that is treated with a mixture of *vajram* (a sort of primer) and chalk to retain its stiffness. The gaada then undergoes what is known as 'service coating' – it is painted with a background colour that would help highlight particular colour tints. (Sometimes this stage is skipped, and artists are known to apply flat colours directly and add in extra tints later.) Young apprentices learning on the job are employed to thus coat the gaada.

While this is being done, the chief artist traces the painting that is to be made into a hoarding onto a glass surface. Holding it against a sheet of transparent glass, he sketches the contours of the painting onto it. This is known as a 'glass painting' and is used to project the sketch onto the gaada. This is done at night or the early hours of the morning, when it is still sufficiently dark, using a powerful lamp, which is shone at the sheet of glass. This magnifies the image and projects it on to the gaada. The projected image is carefully traced out in delicate pencil lines. Doing this 'pencil sketch' is considered a highly skilled job, since it calls for patience, concentration and a steady hand. For if the hand so much as moves unsteadily, the gaada would crinkle and misalign the details of the image. Experienced artists or senior apprentices work on the pencil sketch.

After this, it is time to get the colours ready. The artists use oil paint but they do not buy tubes of paint from the market. These are rather expensive and considered not quite necessary for a piece of work that is not bound to be on display for a long time. (Hoardings last for a maximum of three weeks.) Coloured powders are bought and mixed in the studio to arrive at the required consistency. In this instance too, experience and practice are important. The chief artist supervises the mixing of paints and sometimes lends a hand himself.

Once the pencil sketch stands ready and the colours are in place, the first coat of paint is applied. Apprentices do this mostly, watched over by seniors. After they are finished, the chief artist examines the effects, makes corrections, and then gets to work himself – filling in the contours, adding extra layers of colour, creating a textured surface. Apprentices

'Anything less than 8 x 16 feet I consider miniature painting. I've made hoardings of 30 x 50 feet, and cut-outs of almost 100 feet. We have to stitch several canvases together for the huge hoardings, and for cut-outs, we have to join pieces of painted plywood together onto scaffolding. The street outside my studio is always full of body parts of film stars waiting to be put together.'
– Dhakshna

'We make our own paints as well – you could call it a sort of mixture of oil paint and poster paint. Basically we use powder paints, and mix them with linseed oil to get an oily poster paint. It's a little crude in texture, but we're painting large scale, so it doesn't really matter. I went to art college, so I learnt to sketch, paint watercolours, all that, but I can't really use any of that here. On a hoarding, there's only room for bold strokes, no subtleties.'
– Dhakshna

'Innovations are very subtle – you don't start out fully formed. You watch older artists patiently, and then you are aware of a tradition that is passed down to you. I remember one important thing that one of the companies I worked for introduced: fluorescent colours. First it was used only for lettering, then they started to use \it for borders, and even as background colour.'
– Ragunathan

work alongside, aiding and assisting in these tasks. They finish what the chief artist starts – he leaves the painting to them, once he is convinced that the images are just as he wants them. An apprentice, if he shows promise, is sometimes allowed to do an entire part of the painting on his own.

In the studio, more than anything else, experience and perseverance count. Apprentices are expected to be attentive and do whatever work is assigned them, even if this is only the sharpening of pencils. Only after some time has passed are they allowed to try their hand at painting. This begins with the apprentice first painting in a small grid-like area and then going over the rest of the canvas.

While the chief artist does not usually risk an innovation that is not borne out by the film stills, he does seek to leave his mark on a painting – through a certain sort of brush stroke, a particular combination of colours and a characteristic manner of dividing up and utilising space. Sometimes an artist strives to obtain 'special effects' if his budget allows him and if he is assured of his client's approval. Thus he might try and create special lettering using fluorescent colours; resort to the use of chiaroscuro, if the theme calls for it; bring special compositional skills to bear on the art-work, including novel ways of dividing up hoarding space; create three dimensional effects using tactile materials, such as bamboo rods, woven mats and cardboard artefacts that are then integrated into the hoarding. Such special effects are not always planned and could be created by inspired improvisations. If they help to advertise the film better, the artist's inspirational efforts could secure him a better commission the next time around. If not, he would not risk such bursts of creativity.

Once the hoardings are ready, the transportation team is called in to carry them to their destinations. Simultaneously, the men who do the scaffolding for the hoardings are also asked to get their tools ready. These two groups work to get the hoarding in place. When the hoarding has to be removed, this team is recalled to dismantle it. The surfaces of hoardings are sometimes re-used – turned over and re-painted.

An Ephemeral Life

'You see this place – there's no room for three people in my studio. Our workplace is the street. So we can't store work for clients and start another job. We finish the job, organise transport and take it to where the hoarding has to be put up. We get flooded out in the monsoon, and there's always the danger that fungus will grow on the hoardings if we keep them here too long.'
– Dhakshna

The hoarding occupies a rather curious place in the list of lively ephemera that are produced alongside a film. These include lobby cards, featuring scenes from the film, and displayed at theatres where the film is showing; posters; song books; special preview stories in magazines; audio compact discs featuring songs from the film and innumerable other memorabilia that are produced almost instantaneously.

A hoarding is unlike most of these other pieces of publicity in that it cannot be physically appropriated by film lovers and fans, and transformed to a personal purpose. Yet, given the fact that a hoarding provokes both

recognition and distance – because it appeals to common structures of feeling on the one hand, while casting them in larger-than-life terms on the other – it allows for a peculiar mode of access and engagement. In this sense, a hoarding is perhaps closest in spirit to film posters, which also function in a similar fashion. Posters and hoardings both negotiate a complex zone of interaction between film makers and their audience: the poster is designed to appeal to public perceptions of interest, drama, ethics, emotion and style, whereas these perceptions are themselves constantly subject to what is made available and what is waiting to make itself known.

There are important differences between hoardings and posters, though: for one, hoardings are less mobile than posters. Posters travel widely, are distributed across town, city and village, and while they cannot be bought, are easily acquired. They are thus found on teashop walls, bedrooms... whereas a hoarding is fixed, and usually on display only in larger towns and in cities. This renders the hoarding both monumental, in comparison to the poster, and intensely a feature of urban space. For a hoarding is of a part with the given temporariness that characterises city sights: makeshift homes, unfinished décor, vanishing images – the hoarding, for the period of its existence, appears to encapsulate the colour and uncertain drama of urban grit. Also, a poster's life is shorter than that of a hoarding – it is often pasted over, removed or eaten up by a hungry bovine. A poster is also more protean. It is sometimes made and re-made, in keeping with the fortunes of the film. The hoarding on the other hand is more enduring.

Competing, as it does for visual attraction amidst a veritable forest of colours and symbols that make up the Indian city, a hoarding always seeks to exceed its own functionality, calling attention to itself, as if to say that it deserves to be known in its own right. Thus, the images on a hoarding are far more dramatic and visually eloquent than those on a poster. They breathe out of an expansive, generous space, are anchored in a composition that is both stunningly brilliant in its simplicity, as well as richly associative in its use of detail and colour. The poster's rather modest size limits its appeal. It does not stare down flamboyantly at the urbanite sauntering through the streets, and is less likely to engage the gaze of the proverbial urban flaneur, as he picks his way through the city's dizzy sights.

Hoardings have been used for well over half a century – beginning from the 1940s – and perhaps are most emblematic of cinema advertising. In as much as it seeks to bring the masses to the movies (as the saying goes), cinema advertising also carries with it a certain allure, as if it were letting the layperson into a secret, rendering him or her privy to the deeply mysterious world of make-believe.

'Why are we drawn to this? Because of the cinema, of course. We're in the middle of this whole world, and we actually get to know the stars closely, by drawing them. I ran away from home, hung around theatres and film studios, and finally ended up at a hoarding artist's unit. I've earned a lot in the past, but now that everyone uses flex (computer outputs on vinyl) I have no work. I have to depend on my sons.'
– Ragunathan

'This new stuff, this vinyl, it's just a shadow of traditional hoarding art - like a Xerox of a Xerox. You tell me, can flex ever give you the same effect that a coat of paint applied with a knife can? Don't forget, we use paint to bring the actors to life, give them the mood and character they need. What can a photo show? Just what the actor is. But to bring out the true roughness of the hero needs the artist's hand.'
– Ragunathan

## A Definite History

From the early days of Tamil cinema, film publicity played an important role in creating a constituency that would respond to the charisma of the screen. Artists who created properties for stage plays and films were employed to 'write banners' as the practice was called – that is, to create larger-than-life images on cloth that were displayed at theatres. Later on, special artists known for their graphic talents were employed and eventually banners gave way to hoardings, mounted on wooden frames that were displayed not only at theatres, but also in prominent urban spaces.

Film hoardings owe a great deal to two important moments in modern Tamil history: the moment of popular performances and the moment of popular politics. Early banners – and hoardings – followed the visual grammar and logic of printed 'drama notices' that were in circulation from the early decades of the twentieth century and carried, along with the textual announcement of staging details, images of well-known actors. The stage influenced hoardings in other ways as well – especially in terms of the composition of visuals. Following the conventions of musical theatre, Tamil films featured – and continue to feature – episodic song and dance sequences as well as set comic scenes. Initially, these were offered as 'add-ons' to early silent cinema – as producers and distributors attempted to woo and win their audience. Thus, live performers as well as special comedy clips came as part of a film screening.

Later on, as the silent film gave way to the talkies, songs and comedy sequences came to be integrated into the main film narrative. Further, since the 1920s, an emergent film music distribution industry had so attractively packaged songs from the stage that they could not be left out of films anymore! The industry had also created music professionals out of singing theatre artists and this served the fast emerging talkies well. Since that time – from around the early to mid-1930s – song sequences have come to be part of that peculiar mix of conventions and genres that constitutes cinema in India. Given the importance of these 'extra' features in rendering a film attractive and inviting, hoardings came to feature – almost mandatorily as it were – the comic actor, the flamboyant dancer, the name of the music director...

The political moment that influenced hoardings art decisively belongs to the 1950s. During this time, Tamil public life came to be dominated by the demotic and popular Dravida Munnetra Kazhagam (DMK), a political party representing the great urban underclass, which brought much imagi-native energy and verve to bear on its framing of economic and social concerns. Some of its most important publicists and leaders had been script writers for the stage and film. Their singular achievement was transforming the public performative arena – of the stage – into a space

for effective and spectacular political oratory. They took their cues from several sources, including the Christian pulpit, and created a unique mode of public address that relied as much on allure as it did on semantic and political relevance. As far as film was concerned, they created political scripts that addressed and harangued the audience, with the actors mouthing these lines, looking into the camera while delivering them. Most of these actors were often members of, or at least fellow travellers with, the DMK.

This made for a unique sort of public spectacle, one that was glamorous as well as politically lively. Unsurprisingly, these decades saw the emergence of a visual culture that granted visibility to both. Bold, graphic lines, close-ups of faces marked by an earnestness of feeling, a realism that yet managed to achieve a mythic effect – these came to define the political poster as well as the film banner and hoarding, and, often enough, the same artists produced both.

By the 1960s, this mode of representation acquired a distinctive emphasis as far as film advertising was concerned. It came to be mapped on to an emerging 'star' culture, with the stars in question possessing definite – and opposing – political identities. Hoardings artists now found themselves in a contentious public space: they had to constantly upgrade their work, produce novelties that would allow the stars to do a visual joust in public. This made for a rich and varied display of talents and also produced one of the major innovations in hoardings art: the vertical 'cut-out,' which is actually a giant vertical image of the star rising into the air, trying to dominate the skylines of cities. It was as if the star was actually breaking out of the horizontal space of the hoarding, and of the film text, and affirming his charisma as a thing in itself.

As the star came to dominate the hoardings, the rest of the cast lost out in importance. Early hoardings featured almost the entire cast, in their order of importance. The leading actor and his lady were of course set apart, as were the comedian and villain. But none of the images was entirely subsumed by the 'value' accorded the stars, and each possessed its own iconic charge. Depending on the film in question, a hoarding would call attention to this or that important feature, the dances, songs or sets and properties. Since hoardings also featured text – the name of the film, the producer, director, music director and so on – a nuanced combination of text and image could sometimes achieve unexpected visual effects, but none which eclipsed the importance of the cast and film unit as a whole. But starting from the late 1960s, this changed. As politics and film fed into each other, a new culture of reception emerged – it had less use for the magical charm of the screen, rather it preferred the carefully cultivated melodramatic power of the star, who also exemplified political style.

This development inaugurated other changes as well, many of

'It's hard finding a team to work these days – we are all so scattered now. Earlier, we moved from one hoarding company to the next, and we were always working. Earlier, I wouldn't have had time to talk you – no offence – we were just that busy. But so many of us aren't artists anymore. What do we do? Oh, any odd job that comes our way. Some of us are night watchmen, others have gone back to their villages, to work in the fields. There are a few who're doing all right – there's the odd commission in Dubai or Singapore to paint backdrops or even hoardings. Sometimes there's a job to create a stage for a political rally – that sort of thing.'
– Balu

'Sometimes an actor takes a fancy to your style of work – like Vijaykant took to mine and since then he's recommended me to do the hoardings for all his films. But it also depends on the producer's choice, and I make my choices too – if I know that some producer is likely to pay me late, I skip the chance. But not all actors are like Vijaykant. In the past, during the days when there were real stars, the actors would even drop in to watch us work, but not anymore.'
– Dhakshna

which would become more pronounced in the decades that followed, when the singular attractions of the star, even if he was not particularly political, came to define the appeal of a film. This trend became pronounced in the early 1980s, with the emergence of the 'superstar,' the hero who now dominated filmdom, less on account of his political charisma, and more because he was seen as signifying style and urban edginess. Determined to promote this image, a whole host of persuaders, including film studios, producers and distributors, invested in its constant reiteration. So much so that the cut-out, which once signified a defined relationship between politics and cinema now came to stand in for an icon of a new kind. Earlier, even though it proclaimed the virtues of a singular hero figure, the cut-out marked a significant visual moment in a complex network of public – and political – imagery. Now the cut-out came to exist as the iconic face of a film world that was captive to a carefully cultivated and managed culture of masculine adoration. Interestingly, through this period, the comedian, like the wilful clown in tragedy, refused to go away and continued to retain his visual importance and place in the hoarding (which he does to this day, when hoardings have gone digital).

Hoardings art underwent further transformations in the last decades of the twentieth century: in fact it could be said that for a brief while it ceased to be merely functional. Instead, it came to rely on its own prowess, its art value, so to speak. From the early 1990s, hoardings artists attempted to outdo each other in creating work that was novel in every instance – as they worked hard to transcend convention and custom. It was almost as if the art form was pushing its own limits, on the eve of its eventual demise in 2003–04.

All through its history, then, hoardings art has remained captive to two tendencies. On the one hand, hoardings exist chiefly within the visual as well as material context of cinema advertising. In this sense, it was – and is – one amongst many devices invented by the film world to sustain public attention and interest. This, in fact, has been so from the earliest days, from the time when cinema ceased to be a mere technological novelty and was transformed by enterprising producers and distributors into a branded consumer product. Producers were known, even in the 1940s and 1950s, to pursue measures that would win their films the continued attention and goodwill of their audience. Hoardings achieved this in a most immediate sense.

Yet, in hoardings art we find another impulse at work as well – one that attempts to negotiate its own historicity. This is because the artists get into the spirit of film battles with gusto, and come prepared to do their part. Their art, in the final instance, remains their claim to having made a difference to the success – or failure – of an icon.

# Hoardings Art

Hoardings art is an expression of a public aesthetic that is deployed, both to advertise and persuade a sale as well as to provoke and sustain visual attention and pleasure. This aesthetic has a complex history. Its multiple origins include calendar art, label art, theatre backdrops and cinema.

## Inheritances and Influences

Hoardings art owes a great deal to the impulses that direct label art. Trade labels during the late colonial period drew on freely circulating images of sweetly drawn gods to advertise their wares. For example, the god Krishna in dusky blue and rich yellow garb playing a dainty flute – sketched delicately and in an intriguing mix of colours – was used to advertise 'gripe water' given to infants to help their digestion. Besides the god, the label also carried information about the product, its maker and the reliability of either. This blending of commerce, faith and art worked to not only sell the product but also invoked a sensibility. It produced pleasure, a measure of relish in the buyer, which, more than the qualities of the product, would linger in her mind as a trace of something to which she would return.

Hoardings art too represents such a blending of commerce, art and good faith. Its images help sell a film, in some cases, even seal its fate. Like label art, hoardings too carry names – of the producer, director, music director and several others whose financial and aesthetic roles are seminal to the making of the film. These names, made publicly visible, help to endorse the film even as they assure the viewer that the film being advertised is from a trusted production team or studio. Meanwhile, the art of the hoarding helps anchor

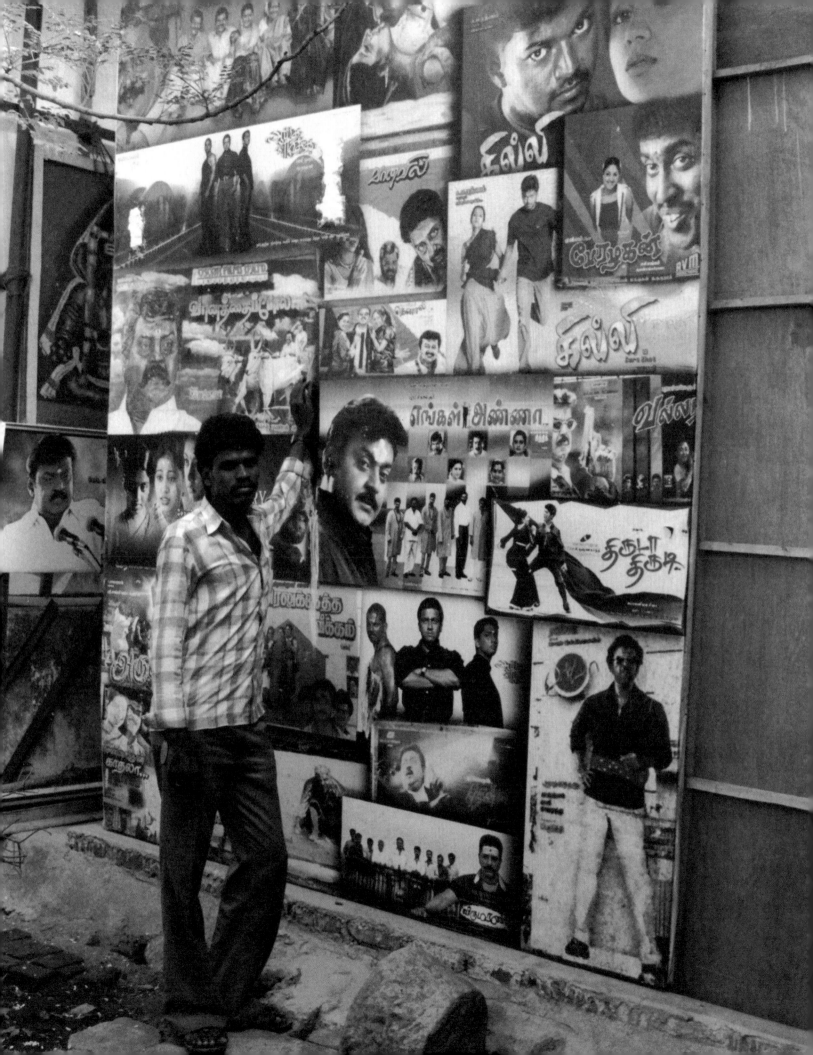

that spirit of curious wonder that is responsible for bringing people back to the movies. It provokes a satisfied relish.

Calendar art too has left its mark on the work of hoardings artists. Calendars in India feature gods, goddesses, 'ladies subjects' (lush portraits of women, usually actresses and pin-up girls in revealing clothes) babies and 'sceneries' (exotic landscapes). Of these, gods and goddesses are the most popular and their representation has come to define the visual character of the form. On festive occasions, retail businesses give away 'god calendars' as tokens of their goodwill (and emblems of their confidence that the customer will return to do business). Notwithstanding this commercial logic that frames their exchange, calendars answer to a pervasive sense of piety that both the giver and the recipient of the gift share. The rich detail and ornate spectacle that constitute the calendar deity mediate a shared visual experience, and allow a momentary retreat of commerce.

Like calendars, hoardings are commercial persuaders, but they too reckon with a shared structure of feeling and appeal as much to a cultural penchant for the spectacular. Where calendars provide a muted, private sense of the fabulous, hoardings invoke a public memory of it. Generally speaking, public displays of power, piety, suffering, wealth and anger in the varied cultures of India tend towards the spectacle. Processions of the gods, public assemblies of political leaders, the enactment of punishment in public, such as flogging, the resistance strategies of radical political groups – all involve drama, oratory and a great deal of colour. Hoardings partake of this common culture in their own characteristic manner. They help 'freeze' memorable moments of feeling and action, imagination and fantasy. In doing so, they provide a context for public appreciation. The world of the film represented on a hoarding holds out a promise, which the viewer redeems by 'agreeing' to watch it.

Between the Real and the Fantastic

In other ways, hoardings are unlike artefacts such as trade labels and calendars. Trade labels – their graphic details, at any rate – are seldom noticed and are far more ephemeral. Calendar art – except with respect to its 'ladies subjects' – features idealised divine forms rather than human character which is a staple of hoardings art. Unsurprisingly, the generation of artists who brought to hoardings art the graphic eloquence we associate with it were originally calendar artists who broke away from the convention of depicting god pictures. But they learnt their draughtsmanship from working on the latter, and this provides us the link between calendar art and the cinema-inspired popular art forms. K Madhavan, for instance, a versatile artist who started off his career painting the divine, soon came to paint 'secular' human types – the honest farmer, weaver, the Tamil woman... His work acquired a distinctive political edge when, in the populist 1950s and 1960s, he began to paint likenesses of popular political leaders. These were not portraits in the strict sense of the term, but graphic representations, which denoted character through inventive brushstrokes.

When Madhavan came to paint cinema banners and hoardings, his art stood poised between the demands of 'realism' and fantasy. For now he had to achieve semblance: the actors had to be recognisable. Yet they could not be merely stars. They had to be portrayed as fictional characters. Madhavan's bold and vibrant brush, steady hand and intuitive sense of colour and line helped him achieve this.

He set a trend that others would eagerly emulate.

The problem of reconciling the star with his role is an aesthetic problem peculiar to art associated with popular cinema. Though it is the star that helps a film succeed, he is adulated only because essentially he is also what he is not. Hoardings artists have addressed this problem of rendering a fictional character and an almost mythic person in the same figure quite ingeniously. For one, the medium helps to an extent. Hoardings are done using local versions of oil paints and artists are not averse to deploying the broad brush rather boldly to achieve texture (sometimes they slap on colour using a knife-like object akin to a spatula). The brush helps produce obviously iconic features, such as wind-swept hair, deep-set eyes, flared nostrils, the twitching mouth and other elements that accentuate the star's charisma. Artists also use the play of light to advantage to reinforce the star's aura, especially in doing the eyes, the face and the background against which the star is portrayed.

The problem is less acute when it comes to portraying women actors. No single woman or even an opposing pair of women has dominated the world of Tamil films, as a male actor or pair of actors has. On the other hand, female actors incite excited interest and their faces and personalities are well-defined in public consciousness. To capture a familiar and desirable likeness as well as the role, artists resort to recording the details of hair and eyes, expressive gestures and costume.

Hoardings artists are helped along in this difficult task by the monumental nature of their art. The size of the hoardings, the fact that people view them from below and a distance means that it is the total effect of the composition that matters, and not this or that particular detail. Thus details that convey character need only be drawn in a formal, almost gratuitous sense. That is, they are not expected to interfere with or compromise star status. Clothes and other accessories, such as a tie, a watch, boots and a hat, flowers, bracelets, the all-important yellow thread or *thali*, which is a symbol of a woman's married status, the bright red vermilion streak that women wear habitually on their foreheads, spectacles, the obvious addition of a beard or a moustache… these, along with exaggerated expressions that mimic actual film moments help the viewer formally distinguish the character that the star portrays in a film from his or her star persona.

Managing Space and Time

What counts as important in this art is the managing of space: what is to be shown and in what manner. While films provide the images, the artist works with a limited number of them, since he is shown only those stills that the film's producer or distributor wish to put out in the public. There is also a temporal issue that the artist has to address in this context. In cinema, visually powerful moments achieve their glory because they represent dramatic turns in the sequence of frames. In a hoarding, though, there is no before or after. Everything has to be shown all at once. A temporal tale has to be rendered as a synchronic event. Dividing up space, creating a visual hierarchy, marking certain images as exceptional and yet sustaining graphic unity – these are challenges that hoardings artists habitually address and resolve.

Artists usually work within a rectangle, reminiscent of film space. Sometimes, a character, usually the star, might leap out of this rectangle – especially if it is an action movie – as if to signify his own elevated status, his transcendence. There

have also been instances of the main characters in a film fashioned as vertical cut-outs, in which case, the rectangle ceases to exist and the hoarding comprises a series of cut-outs strung together. More often, though, the rectangle is what holds the images in place. Images within the rectangle could be single, small, or merely suggested rather than rendered. The hero emerging out of a mass of colours that constitutes his action-field, supplemented by a single modest image of the actress or the comic actor; or a series of smaller images placed off centre, which call attention either to the title, or a dash of colour that figures in the centre of the hoarding – these are enough to make a hoarding work its effects.

Sometimes the star is featured with his leading lady. Her status in the hoarding is determined by the genre to which a film belongs. Hoardings advertising action movies tend to foreground the hero, and the ladylove exists mostly as decorative detail. A hoarding, which portrays romance, on the other hand, focuses on the relationship between the hero and his love. Matching or complementary colours, shaded onto costumes worn by the lovers and the often fantastic frames that hem them in, capture the erotic excitement of their shared visual space. Facial gestures and the use of well-known motifs connoting passion do the rest.

A hoarding featuring a social or family film foregrounds a substantial part of the cast to indicate the film's expansive reach. It does a horizontal assembling of characters stretched across its space. Often it is the figure of the hero that holds this family album or social directory in place. His unitary stature helps anchor the film: he could either stand out of line with the rest of the actors, or offer his profile to help frame the family portrait or the social context in question. The mythological movie or a movie that preaches theism or is about miracles associated with particular sites and shrines pivots visually around the central figure – an actor playing a resplendent goddess, who occupies centre stage, while around her, in various parts of the hoarding, are figures that either revere her or doubt her prowess.

In all instances, infinite variations are possible. Besides suggesting the character of a film and invoking its dominant theme, hoardings also draw attention to what are clearly attractive frills: a voluptuous dancer, a grotesque villain and a comedian. In certain cases, hoardings artists seek to build on the sexual allure of the leading lady. She is placed at the centre of the hoarding, in a position that draws the viewing eye to her immediately. The eye is directed through a plethora of effects: her attractive make-up, the gorgeous details of her costume, the manner in which she is shown to be holding herself, haughty and glamorous. In some instances, she attracts through embodying negative emotions such as fear and terror, which render her sexually vulnerable and therefore asks for the viewer's attentive eye to be bestowed upon her.

The most important factor that artists strive to keep in mind is unity. Unity is achieved through linking disparate elements around either the leading actor or through a symbol or motif which enfolds all elements – it could be a bleeding heart, a rose, a huge teardrop, a pistol, a temple tower, a close-up of a face. Sometimes unity is underlined through a hierarchy of images: the important characters are rendered large and the others in sizes that match their order of importance in the film narrative. Even if a hoarding features an unconventional, unusual style of composition and rendering, whose unifying visual principle is not apparent or clear, it does so because

that particular actor or director is thought of as being offbeat.

Where conventions are flouted, because both the producer and the artist misjudge the nature of a film's appeal and plan for hoardings that appear unusually attractive, then chances are that the hoarding might not really help sell the film.

The Colours of Hoardings

Conventions extend to other details. For instance, there exists a tacit agreement amongst artists and their clients that hoardings ought not to feature sorrow and tears. It is believed that these emotions do not bode well for the film's fortunes. It is not that the film cannot feature these emotions, but that they ought not to be advertised. Frontal nudity is also taboo as is the kiss. (These are not technically permitted in films too, but directors manage to sneak in vastly suggestive shots, which nominally keep within the limits of a tacit erotic decorum, but actually manage to convey sexual want.) As a rule, hoardings tend not to overplay the physical attractions of the 'vamp' figure or even the leading lady, for their intent is to reach as wide an audience as possible, and they do not wish to alienate the sexually conservative lower middle classes and middle classes. However, since the late 1990s, this reticence has been replaced by a measure of sexual explicitness – mirroring the changing sexual mores of an upwardly mobile and aggressively consuming urban middle class.

Hoardings artists also adhere to certain tenets about colour. Rage is always red and deep yellow. In their painting lexicon, romance demands a soft poetic blue and gentle pink. Sorrow requires grey and black embellishments. These strictures are not exhaustive, nor are they mandatory and hoardings art does flout its tenets. This is also because films in India have witnessed a changing history of representing colour on screen. Superior technology has helped film-makers move from an early obsession with 'Eastman' colour to more natural shades. In some cases, hoardings art has accommodated these changes.

Many artists though prefer the characteristic hues and thick textured shades that define their art. Part of the reason for this has to do with the subject matter of hoardings. The Tamil – more generally south Indian – actors that the artist represents are mostly dark-skinned men and women. To set them apart from their peers on the street, artists tend to slap on tints of light and dark pink on their faces. With the male stars, who are invariably superhuman in their prowess, there is the additional need to render faces visually complex – in deep mysterious tones and lines.

Whatever its relation to convention, hoardings art at all times is sensitive to the contingent demands imposed on it by the film at hand. It has to consider – and often does – the manner in which a film is likely to be received into common memory. An artist has to thus engage with public remembering, with what the audience possibly associates with a certain hero or film or theme. For instance, a film whose title deliberately recalls the name of a god or political figure or place tends to build a web of familiar visual associations around its content. Hoardings art responds to this associative web in keeping with its own conventions. It conceives of a visual frame that builds into the painting, iconic traces of the familiar public figure or monument referred to in the title of the film. This helps to position the film into a readymade context of reception. At the same time it sets up a chain of expectations, which only the actual viewing of the film would fulfil.

# Towards an Idea of Reception

If hoardings please and invite viewers to taste a certain fare, they do so in well-defined contexts of reception. Viewers are not, as is sometimes assumed, passive consumers who are the mercy of a profit-hungry industry. Their interest in the industry's wares cannot be assumed and has to be consciously elicited. Even the star's charisma has to be assiduously cultivated and managed. Hoardings, the least pliable of film ephemera, yet depend for their success on how they are received. Viewers clearly engage with hoardings, even if only briefly. In the city, they encounter these gargantuan faces and expressions almost everyday, and are not unaffected by what they see.

This seeing is neither neutral nor innocent. The viewer comes to the hoarding as a social being, gendered, and from a certain class and caste; on the other hand, he or she also confronts the hoarding as a spectator. These viewing positions are not mutually exclusive, and they intersect to produce interesting modes of appropriation and ownership.

## The Male Gaze and Visual Pleasure

Almost all hoardings are directed by the male gaze: they assume their ideal viewer to be a man and appeal to his sense of excitement, dream and fantasy. This is not surprising, since films do this routinely. If women engage with film and hoardings, they do so within the limits of pleasure and reception defined by a gendered logic of viewing. A majority of hoardings feature male actors, if not stars, caught in a moment of virile action or passion. The figure of the actor dominates the space of the hoarding, and, as we have noted earlier, even if women are represented, they exist as little

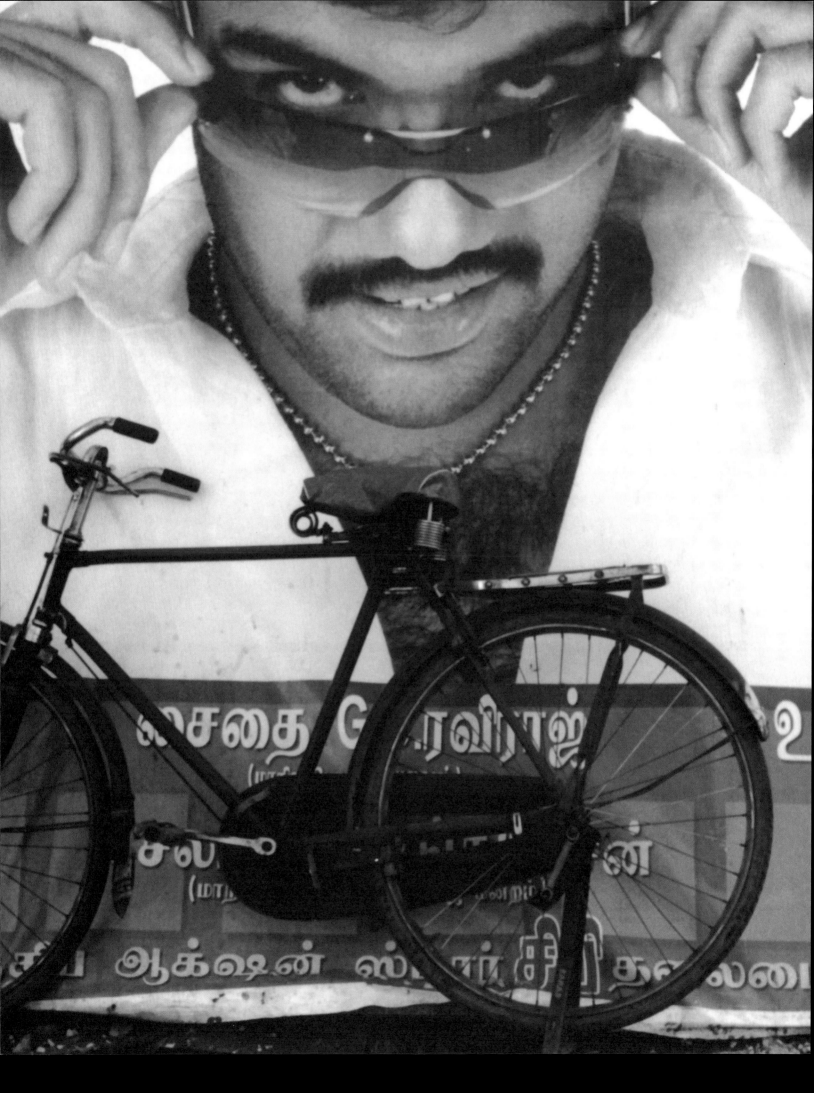

more than pieces of feminine decoration. Even when advertising romances, hoardings tend to portray women in supine erotic poses, literally giving themselves up to the hero, or gazing adoringly into his eyes. The only women who appear to hold their own and whose gaze does not seek the protective, legitimising body of the hero are those 'other' women who hold their bodies proudly and stare out of the rectangle, inviting, instead, the adulatory gaze of the always already male spectator. There is a measure of sexual authority in this showing off, which is immediately compromised by being co-opted into a narrative of male fantasy.

Unsurprisingly, film hoardings and posters have invited the ire of feminists who have protested against what they term 'sexual objectification' of women in a context of public display. Through the 1980s, across India, they took to blackening film posters and, in some instances, even got onto the scaffolding of hoardings and attempted their disfigurement. While the charge of sexual objectification holds true for all hoardings down the decades, it does not perhaps help understand the peculiar and productive form of objectification that films – and hoardings – afford.

For one, such an objectification is linked to visual pleasure. Not only men, but women too are drawn – driven perhaps by a sense of sexual interest and passion, jealous inadequacy or in some instances by active sexual identification with beautiful women – to hoardings. They adulate heroes, in some cases worship them with as much affectionate devotion as men, and admire their leading ladies, and are known to take their fashion cues from film posters and hoardings. Secondly, hoardings, like films, are fundamentally schizoid in their representations of women: they feature both the good and the bad woman, with the former helping to provide the moral anchor to what is clearly a transgressive celebration of female sexual appeal. Thus, even those women who are clearly uneasy with the latter feel affirmed in their sense of 'right' femininity on account of the former (this is clear from their hurried identification with the suffering chaste heroine and their discomfort with the 'vamp' in films). Interestingly, even with some feminists, the argument about objectification easily slides into one of moral condemnation. In some ways then, the sexualised bodies seen on hoardings serve as an incitement to a form of moral rhetoric that is enabling for some women, as the bodies are for men.

Male pleasure at these hoardings is transparent: the hero figure represents virile fantasy, but it is not because the hero is what they cannot possibly be in real life that men identify with him. There is also approval, admiration and devotion. Leading heroes in Tamil cinema have inspired fan associations whose membership runs into thousands. Fans do not only adulate, though; they stake their claim to the hero's image, to what they

perceive to be his 'true' essence and are willing to fight and die for it. They also keep a watch on the hero's career and if it appears to them that their beloved is faltering or giving himself to roles that he ought not to, they are not above rebuking him. This right of censure that they grant themselves is what makes them more than abject devotees. It is not that they are not abject in their love – there have been instances of star cut-outs being propitiated, as one would deities in a temple, before or on the release of the star's film. The point is male identification with the figure on the hoarding is both generous and selfless.

As far as female stars are concerned, men tend to consume images. Several inspired photographs of Indian streets have captured hapless youth gaping open-mouthed at this or that female image, whose body lies athwart the space of a hoarding. This pleasure has become complicated since the decade of the 1990s, when representations of female sexual daring on hoardings invariably invoked the spectre of social class. For the women featured in this manner were often marked as being from the urban, Anglicised upper classes. This rendered them unavailable, chiefly to male viewers from the underclass, provoking both sexual excitement and resentment. Earlier, the leading lady was unattainable on account of her 'purity' and reserve; since the 1990s, she provokes not only sexual thrill, but also a desire for the accoutrements of class and consumption that would render the viewer worthy of women like her.

The Politics of Seeing

This brings us to another important detail about the context of reception: the viewer of films and hoardings is marked by class and caste. In the Tamil context, a majority of film viewers continue to be from the lower castes and classes. Hoardings art is specially geared in terms of its colour, irrepressible energy and graphic appeal to the visual pleasure of this class – a fact that is evident from the censorious objections that middle class viewers raised against hoardings and posters from the early decades of Tamil and, more generally, south Indian cinema. These critics considered hoardings an eyesore, an invitation to debauchery and the dissolute life and as impediments to the development of a tasteful public culture on the one hand and decent cinema on the other. Women, it was argued, could not be expected to be treated with respect in the face of such obvious titillation on the streets and youth would surely grow up with lax morals. Importantly, those who raised these objections saw themselves as superior purveyors of cinema and defined their objective as helping to refine the form and lift it up from its obvious appeal to plebeian taste.

Such critics did not seek to examine the nature of plebeian taste

and how it received the art of cinema. As far as hoardings are concerned, they afford a spectacle of a dream life. But this does not mean that they are viewed only through the lens of alienated longing or consumed as fantasy. As we have noted earlier, the culture of the spectacle is pervasive in the Indian context. It possessed, in the past, two contexts: it was a function of royal pomp and power on the one hand, and enabled exhibitions of public piety on the other. The king or local big man holding court in public was, until the modern period, a phenomenon that allowed the ruler to engage – even if only ceremonially – with his subjects. This practice informed even early colonial interactions with the so-called natives. When the colonial revenue officer of a district visited rural parts, he conducted what was known as a *jamabandi* or a tribunal for tax payers, at which they could expect to pray for a remission or modification of the revenue they owed the colonial state. (Jamabandis continue to this day, and are conducted by free India's revenue officials.)

Such public exhibitions of authority helped establish the ruler as an essentially benevolent personage and also sought his subjects' sanction for that benevolence. In practical terms, these public happenings allowed subjects to direct their grievances at the ruler, than engage with his petty officials. In a fundamental sense, of course, this spectacle of power affirmed feudal and royal relationships – but the fact that such exhibitions were viewed as necessary suggests that even powerful kings felt the need to present themselves before their subjects and seek consent for their rule.

Public spectacle, involving the gods, is a different form of engagement. In most south Indian temples, viewing the deity at close quarters is a practice that the believer waits for. Once the faithful are as close as possible to the god, they seek the deity's grace, which is believed to emanate from the god's eyes. Known as *darshan*, this sought after vision is as much an expression of the believer's need to be in the line of divine sight, as it is of the god's benediction. The eye of the god, as the eye of the ruler, is thus granted magnetic power, as if it possessed a certain charge that directed all seeing to itself. In some instances of worship, this practice of 'seeing' god and demanding to be seen by him or her acquires mystic overtones and results in ecstatic dance and song. This happens not only within the temple, but also outside of it. At regular hours, the presiding deity of the shrine is brought outside its precincts and taken on a procession around the streets that surround the temple. At such moments too believers jostle each other to literally grab a bit of the god's vision.

The idea of darshan is significant, because in some ways, it helps explain the adulation that modern political leaders and film stars inspire. (Political loyalists are known to wait all night for their leader to arrive,

hoping to catch a 'glimpse' of that famous face.) Further, it helps explain a certain practice of spectatorship, which, otherwise would appear merely abject and an instance of mass hysteria. As far as film hoardings are concerned, the unitary image on a hoarding, usually that of the hero confronts the viewer, much as a king in his assembly did or a god in his shrine does. For, it promises a special viewing, almost a darshan, of the star in the film to come and thereby invites the viewer to become an active spectator. By acceding to this offer, a viewer decides to suspend his disbelief momentarily, and surrender to the enchantment of make-believe. In the Tamil context, such surrender implies loyalty, a public exhibition of relish and possession of the desired object. It is not the hoarding alone that makes this possible – as we have noted, the hoarding is part of a complex network of signs that helps communicate a star's aura and the magic of cinema. But, apart from the film itself, the hoarding is perhaps the most spectacular expression of the relish of cinema.

In the Tamil context, the viewing of a hoarding, as if it were a spectacle, is also on account of the interplay between politics and cinema: stars at one time were – and some still are – the bearers of political identities and dreams and to this day, a star is viewed as a powerful mediator of public concerns. Ably aided by a media obsessed with celebrities, stars have sought to live up to this demand, in however peripheral a sense, by investing in safe social campaigns – such as requesting mothers to inoculate their children against polio – and by lending their names to charitable causes. Thus, for the viewer and filmgoer, gaining the 'eye' of the star, even if only metaphorically, assumes great importance.

Interestingly, the power of transcendent vision, whether it is that of a ruler, god or star, even while it depends on the viewer to realise its own importance, also limits the latter's field of action. The subject, believer or viewer/filmgoer acts in his or her capacity as a spectator. This means that he or she is caught within a context of visual pleasure, of relish, which disallows critical action. A fan might rebuke a star and at best desert him, but this does not necessarily imply that he is critical of what bothers him.

In the Tamil context, the continued presence of a public culture of relish has had far-reaching implications. It has created a public sensibility that, for the most part, would rather be pleased and entertained by both politics and cinema than critically analyse either. With the active aid of a public culture of spectatorship, politics, it seems, has been reduced to an eminently pleasurable, though often dangerous, game.

Meanwhile, films continue to enthral and hoardings, as always, hold open an attractive and accessible window to an enchanted world, which is as full of perils as promises.

The Erotic
## 1950s
Created from original film stills

Sentimental, romantic love is a staple of Tamil cinema. Its heyday was the 1950s and 1960s. The painting captures two moments of a tender eros. The one – on the left, featuring 'love king' Gemini Ganesan – mixes love and despair. Unrequited love, a battle of hearts, impending separation or abandonment – any or all of these could result in despair, signified here by what is obviously a dream landscape: a grove on a dusky blue evening, haunted by the light of an incipient moon. The lovers are distinguished not only by their sorrow, but by their elaborate costume. The second image – on the right – is the very obverse of the first. It signifies happy waiting, as the woman dreams about her beloved. Such a moment of wistful dreaming is an important trope in classical Tamil love poetry and was often invoked in films of this period. The loved one appearing on the pages of a book – or the still waters of a lake, in a trace of clouds in the sky – is a visual motif that recurred in several films. The book as a motif signifies that the lovers are educated and that theirs, there-fore, is an elevated passion.

The Erotic
## 1960s / 1970s
A montage of original film stills

The 1960s saw the emergence of the 'star system' – with successful actors dominating the public sphere, on account of their screen popularity and political affiliations. The stars though were actually ageing heroes. Among other things, they attempted to retain their place in the film world by acting with obviously younger women. M.G. Ramachandran, one of these ageing men who went on to become chief minister of the state of Tamil Nadu, did more: he had deliberate recourse to crude sensuality in his films. Titillating symbolism and suggestive film lyrics that usually accompanied close-up shots of lovers in the throes of sexual want created a new formula for romance. This painting (which mimics the glorious colour of the original stills) narrates the details of this formula: pot of milk, the umbrella stand, which help to position the entwined lovers for the audience, and the visual staging of female desire.

The Erotic
## 1970s / 1980s
Created from original film stills

Love in the Tamil context, as elsewhere in the world, turned youthful in the 1970s. In fact romance and youthfulness came to be coded in terms of each other. This coding was funda-mentally masculine in intent and introduced two sorts of screen heroes, who went on to become romantic archetypes for their peers: the one was self-confident and narcissistic, while the other emerged – gradually – as a larger-than-life man of action. The one affected an impudent sexuality, and the other cultivated an urban virility that revelled in danger and socially disreputable style. Done in a style, reminiscent of 1980s hoardings art, this paint-ing captures these two archetypal lovers in action. In the picture on the left, the heroine exists only to display male desire – the scene is a Tamil dream version of the permissive life. A confident dashing hero and his brash lady love are featured on the right: her boldness mimics his 'style.' The pair expresses brazen intimacy – symbolised here by her hat and his waistcoat, which recall the purportedly dare-all culture of the Hollywood Western.

The Erotic
## 1960s / 1980s
Created from original film stills

After the 1960s, when ageing heroes negotiated their star status through coveting impossibly romantic roles, the erotic itself underwent a transformation. It came to be associated with an opulent lushness, a trend that continued into the 1980s. Earlier, only the 'vamp' was expected to bare her body, but now even the heroine was expected to show a leg or agree to a top-down shot of her breasts. This resulted in film sequences and frames whose only purpose was to portray explicit – and unrefined – sexual imagery. This painting, in the manner of a 1980s hoarding, attempts to capture the visual tenor of such imagery. Both sets of images were chosen chiefly for the symbolism of well and water in the one instance, and the crude metaphor of the pump in the other.

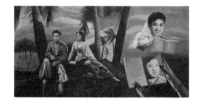 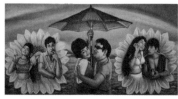 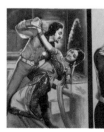 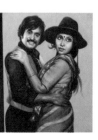 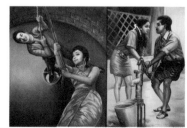

## The Erotic
### 1980s
Created from promotional images

The late 1970s and especially the 1980s saw Tamil film court the countryside. While there has always been a 'rural' film, one that praised the innocence and moral uprightness of the country versus the city, the camera seldom travelled outside the precincts of city studios to actually shoot fields, farms and peasants. With the advent of Bharathi Raja, a director who has since come to be associated with the countryside, all this changed. The subtle shades of green that make up the Tamil field and forest entered cinema, providing an ideal backdrop for rural romance. This painting, conceived as a tribute to the landscapes of village love, portrays a rather unusual pair – a young woman and an older man. Its 'rural' character is evident – the bare-shouldered woman is an 'ideal' rural 'belle,' and the man a somewhat alienated peasant.

## The Erotic
### 1990s
A pastiche of film stills, clip art and fragments of memory

Love in Tamil cinema turned global in the 1990s. The growth of a distinctive urban culture, the ease of travel, the availability of exotic 'foreign' images due to the advent of music television: these helped romance anchor itself in not merely exotic locales, but to express itself through a new, cool cosmopolitan feel. Even so, an older sentimental sense of the erotic never quite deserted the Tamil screen. As this painting demonstrates, in classic 1990s hoarding style, on the one hand, love is still a matter of the bleeding heart and the old song-and-dance routine. On the other hand, romance is also cavorting under the Eiffel tower and the New York skyline. Love, thus, is all style and convention, a pastiche of form and content, half-serious and half-ironic.

## The Valorous
### 1950s / 1960s
Created from three different stills

Valour is an old fashioned emotion, linked as it is to notions of chivalry and honour. A persistent feature of early Tamil cinema, it was best embodied by M.G. Ramachandran, whose best films were made in the late 1950s and 1960s. He was valorous in fighting for the cause of social good, defending his lady's honour, or honouring his mother's vow. Part of his appeal was the protective charm he exuded, as well as his panache and desirability – all of which were coded into his costume and body language. This painting, which mixes and matches the sepia of old stills with the colours of 1980s hoardings art, shows him in two characteristic modes – a fencing gallant and a modern day hero, who sports the looks of the American frontier. The woman in the painting – standing in for all that the chivalrous hero has to defend, including tradition and culture – is Saroja Devi, who played his leading lady in several successful films.

## The Valorous
### 1950s / 1990s
Created from two different stills

Valour in contemporary cinema, in fact since the 1980s, is no more a function of old-fashioned honour or chivalry. The gallant has given way to a rather angry hero, who takes umbrage at injustice and social wrong, especially the corruption of law and authority, and who wields his prowess and weapons to do right. (For the earlier type of hero, his weapons were accessories that marked him as different, rather than actual implements to be used.) This painting, typical of the spectacularly colourful hoardings art of the 1990s, does two things. It shows the new in the shadow of the old, and it calls attention to the new through a portrait of one of the most obviously angry yet heroic men to have ruled the Tamil screen since the 1980s – Vijaykant, whose red-eyed rage and composed acting have made him a new type of valorous hero.

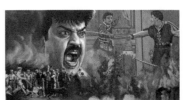

The Furious
## 1980s / 1990s
Created from three different
hoarding images

Anger in Tamil cinema
has defined hero-hood for over
twenty-five years now. The
furious hero – or rather, anti-hero
– emerged in the late 1970s.
He was neither transparently
righteous nor chivalrous; rather
he was poor, rough and prone
to violence, but essentially
golden-hearted. This painting,
featuring a distinctive 1990s style
of hoardings art, shows three
heroes who have re-interpreted
anger as a socially useful emotion.
The first is Rajnikanth (first from
left) who was himself from the
underclass, and went on to become
an invincible man of just action.
He endeared himself to city
youth and women – speaking
Tamil in a rush of vocal energy,
twisting and turning his slim
body in a series of sharp jerks,
throwing his head back, so that
his thick, straight hair flopped
back stylishly. He has since
become a veritable icon. The
others in the painting include
Vijaykant, who has since become
identified with responsible angry
roles and Arjun, on the far right,
who preaches and acts from
a sense of patriotic zeal.

The Furious
## 2000s
Created from images on posters
and hoardings

The angry hero in films made
after 2000 is essentially violent,
many times it appears that in
these films violence is intrinsic
to an expression of personal
character as well as social anger.
Characteristically, the playing
out of anger happens in busy
markets, where the hero kicks
at wares and pedlars, breaks shop
windows, fights local gangsters;
or it unfolds in decrepit public
places, such as abandoned
railway tracks or a ruined temple.
The hero faces the camera
fearlessly and this helps to mark
fury as a necessary and credible
emotion – in the 2000s, anger is
not so much associated with the
actor as it is with the role.
Hoardings art after 2000
inherited colour and energy from
the previous decade, but wielded
a characteristically brutal brush:
this painting features aggression
for the twenty-first century: of
these violent headstrong men,
it is not immediately clear which
of them is angry in the cause
of right, and which merely
malevolent.

The Furious
## 1970s / 1990s / 2000s
A montage of clips from diverse
films

Female rage is an identifiable
feature in Tamil films. The angry
mother who inspires her son
to avenge her sorrow or dishonour,
the enraged goddess who wreaks
vengeance on those who do evil,
the angry 'other' woman who
is both jealous of the heroine and
desires the hero, the domestic
woman whose anger is an
expression of hideous pride…
This painting, which keeps to the
colours of the films in question,
portrays some of these angry
women: from the sword-wielding
outcast woman who fights for
social justice to the whip-lashing
domestic harridan. The painting
is dominated though by a woman
who is both sensuous and vengeful
as the figures in the centre
indicate: beautiful and angry
in her youth, she turns murderous
in her middle age.

The Terror-stricken
## 1980s
Created from two different stills

Terror has always been a gendered
emotion in Tamil cinema.
Women exemplify this emotion
more than men (with men, terror
becomes a mark of cowardice).
Terror is most often experienced
in and though sexual vulnerability.
But women also fear other things,
the dark, for their husbands and
children, their honour… On
screen fear and terror are distilled
through several well-worn tropes.
A favourite mode has been to
show women having to keep an
unhappy secret and suffering
fearfully for it. Through recourse
to the classic film close-up, this
painting describes that uneasy
fear experienced by one who has
heard something she cannot
share with the outside world. The
rough looking man beside her
might be the cause of her clearly
psychological turmoil. The
telephone, an important motif in
several Tamil films, serving as
a symbol of communication and
a bearer of ill tidings, is featured
prominently.

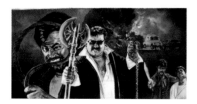

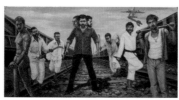

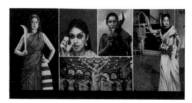

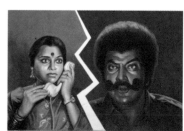

The Terror-stricken
## 2000s
Created from an original flex
hoarding for a film

Fear is both clearly and tangen-
tially linked to love. A woman
fears for her beloved and some-
times fears him, before she learns
to love him. Since the late 1980s,
love in Tamil cinema has
attempted to replace courteous
and romantic wooing with an
impassioned and often unmindful
love that a man seeks to impose
on a woman. Love and violence
thus are brought very close
to each other. This painting
represents the nature of fear that
will soon turn to love: in older
films, fear is caught in and
through close-up shots,but
with the new sort of fear, which
involves the 'love chase,' the
narrative turns dramatic, and the
viewer is left wondering, as
we are, with this painting: is the
man her tormentor or protector
or both?

The Pathetic
## 1950s / 1970s
A montage of a film still and
poster

Sorrow is not usually featured
on hoardings, since a portrayal
of it is considered inauspicious.
However, sorrow is a fundamental
feature of all Tamil film narra-
tives, affording as it does great
visual moments. Both men and
women feel sorrow, experience
a sense of pathos: but whereas
men realise this emotion chiefly
in the context of unrequited
love and what appears to them
emotional betrayal, women
sorrow for both being and not
being in love, for being unhappily
married, for not having children,
for being born female… the list
is endless. This painting done
in the graphic style of the 1970s
hoarding represents generic
female suffering and pathos –
complete with tears, and under-
written by a visual rhetoric
of selflessness and sacrifice.

The Pathetic
## 1960s / 1980s
Recreated from film clips

Unrequited love that is an almost
uniquely male condition in most
Tamil films is often the cause
of sorrow in men. A fit subject
for sentimental tragedy, it has
attracted several visual motifs,
including a face cast permanently
in pensive sorrow, a wasted
body… This painting simulates
the nostalgia that is often the
generic context of this kind of
sorrow. It takes its visual cues
from the deliberate formal
symbolism of love in cinema
(the two birds, for example) and
a cult campus movie of the 1980s,
set for the most part on board
a train, which created a long-
lasting archetype of the sad,
misunderstood youthful lover.

The Comic
## 1950s / 1960s
Created from an original film
still and a poster

Humour in Tamil cinema
is situational, verbal and slapstick.
Complications in the love plot,
lost and found twins, parodies
of the protagonists' sentimental
or tragic dilemma make for comic
moments. A fair amount of
comedy is satiric in intent as well.
On screen, the comic moment
and comedian are easily distin-
guishable: facial distortion, the
mismatching of person and role,
person and clothing, in general,
the drawing together of incongru-
ous elements index the comic as
an experience. Comic actors have
always had their pride of place on
film hoardings and help to bring
in the crowds. This painting
blends stills featuring a lightly
portrayed love triangle, always
an occasion for comedy, and typi-
cal images from a 1960s poster
for a comic film.

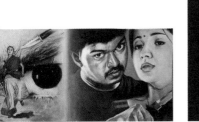
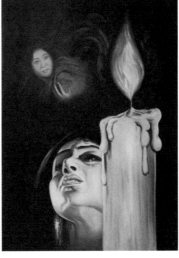

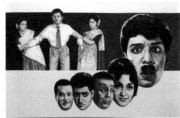

The Comic
**2000S**
Recreated from a film poster

Humour in Tamil cinema
is mostly obvious. Full length
comic films which enjoy tremen-
dous popularity communicate
through a mix of symbols:
mismatched situations and
characters, sophisticated
misunderstanding, an impossibly
mixed-up plot... This painting
deliberately announces its
emotion through framing the
comic in a style that is visually
transparent and even excessive.

The Disgusting
**2000S**
Recreated from film clips

Disgust is less an emotion in itself, and more a response to an emotion.
In Tamil cinema, it is arch-villainy that incites disgust. Through there
have been attempts to grant dignity to the proverbial bad men of
cinema, the villain remains an easily recognised object of terrified
fear and disgust. His physicality, mannerisms and smile, indistin-
guishable from a grimace, mark him out from the rest of humanity.
These two paintings, rendered in a rather free-floating hoardings style,
feature two villainous figures. The one is easily knowable through
his contorted face that is knit into a permanent angry sneer. The other
is an instance of startling villainy: the woman who looks tough and
unpleasant is based on a foul-mouthed local female politician who, since
the 1990s, has earned the ire of the public on account of her aggressive,
bullying manner.

The Marvellous
**1950S / 1980S–2000S**
A pastiche of films stills, film
ephemera and film clips

In Tamil cinema, exotic and
unknown worlds incite marvel
and wonder. Wonder is made
resident in tourist landscapes,
mythic places and exists on
screen chiefly to dress up and
augment romantic interludes.
In the past, producers of Tamil
films travelled to Switzerland
and Singapore to shoot their
romantic sequences. Over the last
few years, Europe and Australia
have emerged as favoured
destinations. Wonder is also
simulated through cleverly
designed sets – the Taj Mahal
and the Great Pyramid have
been recreated by generations
of art directors. Importantly, the
marvellous is never allowed to
get alien – it is localised through
a rhetorical invocation of Tamil
identity, either in the song
sequences, or the clothes of the
leading pair, or in the turn of
the plot. This painting is all about
the varied landscapes of wonder.

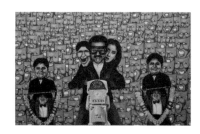
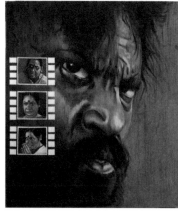
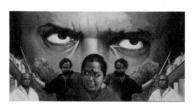
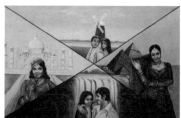

The Marvellous
## 2000s
Recreated from film clips

Along with a penchant for exotic, lush landscapes, Tamil cinema has continued to be inspired by the so-called promises of clever, slick technology. This fascination with technology has resulted in a sort of techno-pop culture, most evident in the alacrity with which Tamil people have taken to the new forms of communication, including the internet. As far as cinema is concerned, this fascination has come to be explored – from the 1990s onwards – through what is best described as 'visual rap', comprising sharply edited images which are put together on the basis of a dizzying graphic logic learnt from worldwide music television. This painting, based on a clip from a 2005 movie, is of its times.

The Peaceful
## 1960s / 1980s
A pastiche of film ephemera, calendar art, movie stills

Peace and serenity are not easily found in Tamil movies – it is only the happy ending that brings the infectious raucous energy of this form to a quiet conclusion. Yet there have been attempts to portray the serene life and praise the virtues of quiet and humble piety especially in films devoted to an affirmation of theism. Such films sought to answer atheism, which enjoyed considerable public – and political – visibility in Tamil society in the 1960s. This painting brings together motifs from spiritual cinema and calendar art to represent an emotion that eludes understanding and visual representation.

Thirty-four-year-old M.P. Dhakshna has been painting hoardings for over 15 years. He started as a teenager and continued to paint through the five years he studied at the College of Fine Arts in Chennai. Known for his dramatic use of colour and novel compositional skills, Dhakshna is considered one of the most talented hoardings artists to have emerged since the 1990s. Dhakshna has won several awards for his work.

Dhakshna works with a floating team of artists – comprising men he has worked with previously and also new ones. Some in the team are older than Dhakhshna and bring with them the experience of having worked for over two decades and in other studios. Others have recently earned their place in the team by starting as apprentices. His team members possess a wide repertoire of skills and do everything from knocking together the frames for the canvas to working on finer details of a painting, and mounting them onto giant scaffolds.

For *The 9 Emotions*, Dhakshna worked with Balu, Raghunathan, and Chandrakanthan (L to R).

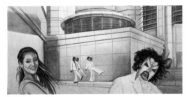
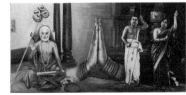

# References

Baskaran, Theodore S., *The Eye of the Serpent: An Introduction to Tamil Cinema*.
Madras: EastWest Books (1996).

Blamey, David and Robert D' Souza, (eds), *Living Pictures: Perspectives on the Film Poster in India*.
London: Open Editions (2006)

Dickey, Sara *Cinema and the Urban Poor in South India*.
New Delhi: Cambridge University Press (1993)

Mazumdar, Ranjani 'The Bombay Film Poster' in *Seminar* 525

Menon, Dilip 'The Kiss and Bhagat Singh' *Seminar* 525

Nandy, Ashish (Ed). *The Secret Politics of Our Desires: Innocence, Culpability and Indian Popular Cinema*.
New Delhi: Oxford University Press (1998)

Narayanan, Arandai *Tamizh Sinimaavin Varalaru*
(History of Tamil Cinema)
Madras: New Century Book House (1981)

Pandian, M.S.S. *The Image Trap*.
New Delhi: Sage (1992)

Srinivas, S.V. 'Devotion and Defiance in Fan Activity' in Ravi Vasudevan (Ed.),
*Making Meaning in Indian Cinema*,
New Delhi: OUP, (1999), pp. 297-317

'Is there a Public in the Cinema Hall?'http://www.frameworkonline.com/42svs.htm

Srivatasan, R *Conditions of Visibility:*
*Writings on Contemporary Photography in India*.
Calcutta (2000)

Vasudevan, Ravi 'The Exhilaration of Dread: Genre, Narrative Form and Style
in Contemporary Urban Action Films', *Sarai Reader* 2: *The Cities of Everyday Life*

The 9 Emotions of Indian Cinema Hoardings
Copyright © 2007
Tara Publishing Ltd., U.K., tarabooks.com/uk
and Tara Publishing, India, tarabooks.com

Hoardings  M.P. Dhakshna
Script  V. Geetha
Art Director  Sirish Rao
Concept  Gita Wolf
Photography  Helmut Wolf
Production C. Arumugam
Book Design  Natasha Chandani, localfarang.com

Printed and Bound in Thailand by Sirivatana Interprint PCL

ISBN: 978-81-86211-27-6

The Authors and Publishers would like to thank
Trotsky Marudu for his generous and invaluable inputs
Wim Pijbes at the Kunsthal, Rotterdam for his support in the early stages of the project
Hivos for their research support
All the fans of Tamil films who helped us source songs and images

Excerpts from *Natyashastra* have been re-worked from a variety of translations
and pertain to chapters 5 and 7 of the original Sanksrit text.

The clips of film songs that accompany the art refer only to the emotion being portrayed,
and do not necessarily pertain to the particular image or film still shown in the painting.

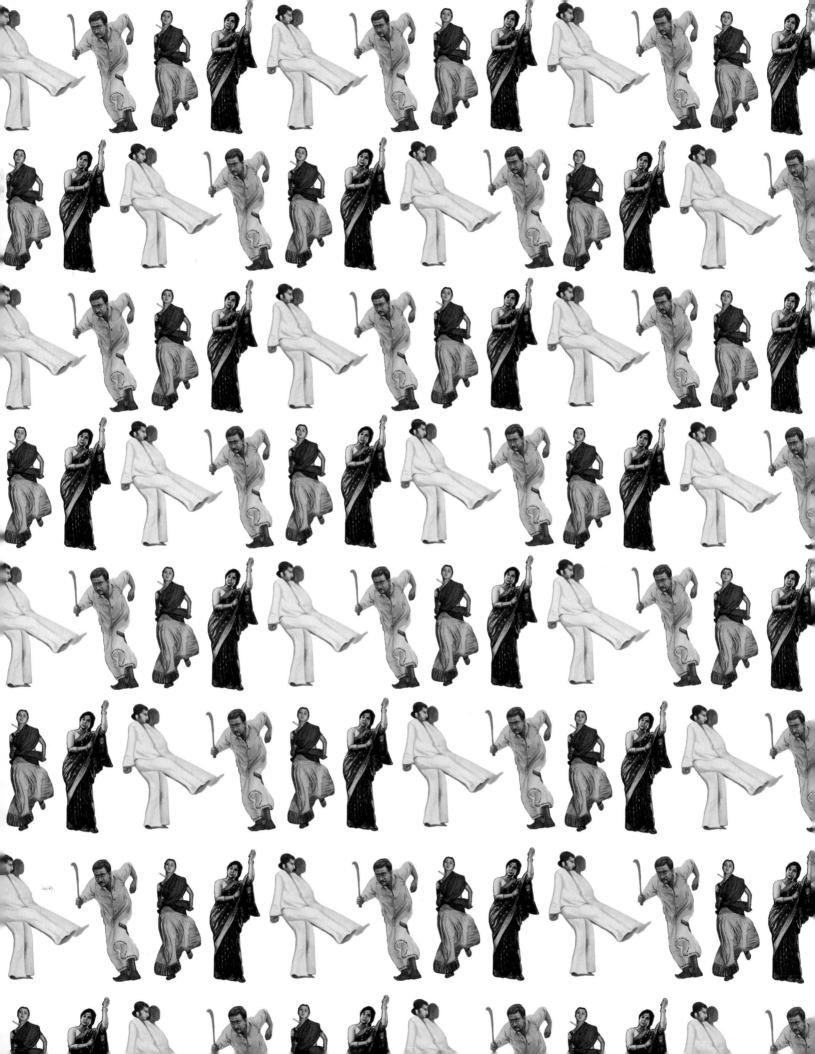